Untitled (Seated Female Figure)
Watercolor and pencil, 5¾ x 4⅛. 1935
Courtesy Marlborough–Gerson Gallery, N.Y.

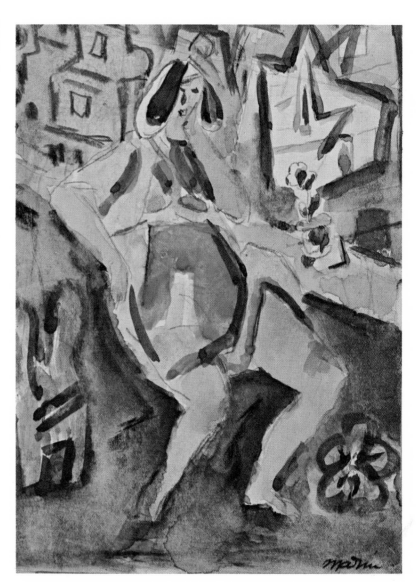

JOHN MARIN

DRAWINGS
1886–1951

BY SHELDON REICH

A Retrospective Exhibition
Honoring John Marin's Centennial.
Organized by the University of Utah
Museum of Fine Arts.

University of Utah Press

CONTENTS

ITINERARY OF THE EXHIBITION

1969

September 13–October 12
Munson–Williams–Proctor Institute
310 Genesee Street
Utica, New York 13502
 Mr. Edward H. Dwight, Director,
 Museum of Art

October 25–November 23
University Gallery
University of Minnesota
Minneapolis 14, Minnesota
 Mr. Allen J. Davis, Acting Director

December 6–January 4
State Museum
Cultural Center
Trenton, New Jersey 08625
 Dr. Kenneth W. Prescott, Director

1970

January 17–February 15
Tangeman University Center
University of Cincinnati,
Cincinnati, Ohio
 Joan Cochran, Director

March 1–31
University Art Museum
23rd and San Jacinto Streets
Austin, Texas 78712
 Mr. Donald B. Goodall, Director

1970

April 15–May 17
Bowdoin College Museum of Art
Walker Art Building
Brunswick, Maine 04011
 Mr. Richard West, Director

June 1–30
Oklahoma Art Center
3113 Pershing Boulevard
Plaza Circle, Fair Park
Oklahoma City, Oklahoma 73107
 Mr. Patric Shannon, Director

July 15–August 30
Corning Museum of Glass
Corning Glass Center
Corning, New York 14832
 Mr. Paul N. Perrot, Director

September 13–October 4
Krannert Art Museum
University of Illinois
Champaign, Illinois 61822
 Mrs. Muriel B. Christison,
 Associate Director

October 17–November 15
Amon Carter Museum of Western Art
3501 Camp Bowie Boulevard,
Fort Worth, Texas 76101
 Mr. Mitchell A. Wilder, Director

FOREWORD AND ACKNOWLEDGMENTS

In 1956, three years after John Marin's death, a memorial exhibit—"because John Marin was a great artist"—was organized at the University of California at Los Angeles by Frederick S. Wight and circulated to a number of major museums. In the book which came from that exhibition Dr. Wight wrote that "Marin's art rose in three waves, his etchings, his watercolors and his oils—and it is not certain that the third wave is not the greatest." As there were during his long lifetime, there have been many exhibitions since Marin's death devoted to his oils and watercolors. And just this year, the Philadelphia Museum of Art prepared a documentary exhibit of the graphic work.

But an extremely important part of Marin's oeuvre intimately connected with Dr. Wight's "waves" has never been given much attention. The reference is, of course, to Marin's drawings. Very few are in public collections, although almost every museum with holdings in American art lists a Marin watercolor or oil. There had been no retrospective view of his drawing achievements. This book comes from an attempt to provide such a retrospective: 93 drawings dating from 1886 to 1951, organized by and exhibited first at the Utah Museum of Fine Arts of the University of Utah from 20 April through 18 May 1969. After the Salt Lake City showing, a major part of the exhibit traveled to a number of other museums (itinerary precedes this foreword) under the sponsorship of Mrs. John A. Pope and the International Exhibitions Foundation, Inc., of Washington, D.C.

The exhibition would not have been possible at all without the generous help of Mr. and Mrs. John Marin, Jr., of New York. The Marins provided encouragement and knowledge (and not a little patience) in the preparation of the exhibit, and allowed their holdings to travel over the country, as well. The other public and private lenders to the exhibit in Salt Lake City were gracious in giving up their prizes for our purpose. They are all listed in the catalogue of this book.

Dr. Sheldon Reich, probably the leading Marin scholar, has written a significant essay examining John Marin's drawing accomplishments. Dr. Reich is Head of the Art History Department of the University of Cincinnati; his catalogue raisonné of Marin oils and watercolors is a publication of the University of Arizona Press. Professor Reich selected most of the drawings in this exhibition, and he will lecture at several of the museums where the exhibit will be shown.

Mr. Donald McKinney of Marlborough-Gerson Gallery, Inc., New York, was a source of immense assistance in the technical matters relating to the preparation of the exhibit and of the subsequent tour. The Dean of the College of Fine Arts of the University of Utah, Edward D. Maryon, facilitated all phases of the exhibit. Mr. Keith Eddington of the University of Utah Press has designed the book. The impression on the cover of the catalogue is drawn from Gaston Lachaise's bronze bust of John Marin lent to the exhibition by the Milwaukee Art Center. Members of the Museum staff, particularly Mr. Jack Hicks, prepared the exhibit for circulation.

E. F. Sanguinetti, Director
Utah Museum of Fine Arts
University of Utah

"I feel that what will be written
will fall short of being
a thing of clear reasoning.
It's too damned important and
almost unanswerable.
Has art itself ever been defined
so that many men can say,
there's the definition?
Art is a Will-O-the-Wisp.
One of the first articles you showed me.
It was the side steppings of a dancer,
though may be that's as far
as any of us will go." JOHN MARIN

THE DRAWINGS
OF JOHN MARIN
BY SHELDON REICH

In this essay, references to "Catalog no.
correspond both to the numbers above
the upper right-hand corner of each
subject in the Illustration section,
and to the numbers in the Catalog section.

There is no doubt that John Marin is most widely known as America's great watercolorist—a reputation well deserved. To those familiar with his art, he is also a significant print-maker and painter in oils. However, the number of those who are acquainted with his drawings is small indeed. Yet knowledge of these drawings confirms the fact that Marin was one of the outstanding draftsmen of his period.

Over the years there have been many opportunities to see Marin's work as a painter, but exhibitions devoted exclusively to his drawings have been very rare. This scarcity itself is important because it suggests that Marin's drawings have, for the most part, remained a private part of his artistic effort. To see such drawings, therefore affords an opportunity to gain insight into Marin's creative thought processes. Never intended for public view, some of the drawings reveal much because "the artist's creative tension is relaxed, and he follows instead an unconscious habit, which by its very unconsciousness is personal enough to sign his work."[1]

John Cheri Marin III was born December 23, 1870, in Rutherford, New Jersey. His mother died shortly after his birth and he was brought up by his maternal grandparents around Weehawken, New Jersey. Marin's love of the rural landscape may be explained by this country upbringing, but the part of New Jersey he grew up in is directly across the Hudson River from Manhattan—close enough so Marin could, in later years, look over the river to the New York skyline and use the motif in numberless drawings and paintings. In any event, it was with the Curreys, grandfather, grandmother, and aunts Jenny and Lelia, that Marin found his home and closest family. His father, traveling because of his profession, saw him rarely during these formative years.

As a boy of seven or eight, Marin demonstrated a precocious interest in art by executing a number of pencil sketches.[2] None of these has survived, but the earliest extant dated drawing by Marin—done in the Catskills near Slide Mountain in 1886—is remarkably accomplished for the work of a sixteen-year-old (Catalog no. 1). The rendering is a straightforward, albeit somewhat meticulous, realistic approach to landscape. Despite the natural skill shown, there is something awkward about the drawing that stamps it the work of an untrained artist. Perhaps it's not awkwardness alone that marks it as an amateur's effort, but a kind of persistent, determined lack of style.

As the earliest dated work by an artist who later achieved such fame, the **Catskill Mountains** has a clear historical significance. For one thing, as early as 1886 Marin's interest in a mountain landscape is expressed. This interest spanned his entire career as an artist, as he searched out such subjects from the Austrian Tyrols to the White Mountains of New Hampshire, from the New Jersey Ramapos to the New Mexico Sangre de Cristos. A point of perhaps even greater significance, the landscape of 1886 is devoid of people. Much of Marin's depiction of nature is notable for its lack of human presence. When figures do appear, in the early pictures in particular, they are often small, insignificant, blended into their surroundings. At a later time Marin verbalized this attitude: "Mountains, streams, trees and rock are so sympathetic. Damned if I find most humans so."[3]

Thus, despite the fact that stylistically the 1886 drawing has almost nothing to do with Marin's future artistic develop-

ment, it appears already to embody an attitude toward nature that remained an important component of his art throughout his creative life.

Marin did not attend art school until 1899. However, between the first drawing of 1886 and the start of his student career at the Pennsylvania Academy of Fine Arts, he sketched continuously and painted watercolors. He traveled in the summers—going at least as far west as Wisconsin—filling small notebooks with drawings. Related closely to the notebooks are the two pencil drawings **Vicinity, West New York, New Jersey** and **Bull's Ferry Road, West New York, New Jersey** (Catalog nos. 2 and 3). These, for the most part, show increased conventional skill. In 1893 Marin worked for awhile as an architect, and the sketches in the notebooks, as well as others from the same period, may reflect his architectural training.

In subject, the drawings are chiefly of buildings, views of towns, and small corners of countryside, all rendered in a soft, silvery tone, suggesting a landscape permeated by a delicate light and recalling the impressionistic watercolors also being done by him in these years.

Recent evidence, providing a date of about 1892–93 for the notebooks, probably also establishes a reliable date for the two drawings represented here. They were done, therefore, before his tenure at the Pennsylvania Academy.[4] There is, however, no sharp break between his work before and after 1899. If Marin had been at the Academy during Eakins' time, he would have developed, probably, a more precise realistic

technique. While he did study with Thomas Anshutz, one of Eakins' students, the dominant tone of the school was set by its most famous teacher, William Merritt Chase.

Chase was one of the most prominent representatives of the so-called Munich school of painting in the United States. Actually, the kind of painting Chase advocated was related, stylistically, to Manet's work of the 1860s, especially in the admiration shown Hals and Velasquez. Connected also to Whistler's art, Chase developed a kind of dark, romanticized Impressionism.

Paying lip service to realism, Chase did not like things spelled out too precisely. He preferred instead a loosely painted view of his subject so that, like French Impressionist paintings, one has to take a certain distance from the picture for it to coalesce into a representational meaning. Except for the fact that Marin's drawings (and watercolors) at this moment are somewhat softer, more introspective in mood than Chase's more robust works, they are within the general sphere of what the older man was preaching. An indication of how in tune with the times his drawings were may be gotten from the knowledge that the first official recognition came to Marin at the Academy through his drawings— he won a prize.

Marin told his biographer that while he was at the Pennsylvania Academy of Fine Arts he was an admirer of Whistler. Perhaps his interest in Whistler partially explains the difference in the nuance of feeling between Marin and Chase. Contact with Whistler's art and ideas would have directed him to a softer, more poetic view of the world. An artist in Whistler's circle wrote, defining how far the view of aestheticism had progressed among his group: "Nature,

we said, is for the painter a decorative patch; a portrait of a blotch of colors, merely an object in relation to a background."[5] The lightness and delicacy of some of the early drawings may reflect this jaded view of the world.

The attitude of Whistler would, for Marin, be reinforced by knowledge of the landscapes of George Inness, particularly the misty (and most popular) canvas of the last years of his life. "What is art, anyway?" Inness asked his son. "Nothing but temperament, expression of your feelings."[6] This remark is quite in keeping with the mood of resurgent romanticism here and abroad, and Marin's early pictures—those done before his trip to Europe in 1905—reflect this cultural milieu.

When Marin decided to go to Europe early in the summer of 1905, he'd completed about two years at the Pennsylvania Academy and, about 1903, enrolled for a brief stay at the Art Students' League in New York City. This last experience he preferred to write off as: "1 year Art Students' League, N.Y., Saw KENYON COX."

Once in Europe he made for Paris and there joined his stepbrother Charles Bittinger and Charles' wife Edith. They found rooms on the Left Bank, in Montparnasse, at 3 Rue Campagne Première. It was an excellent location: close to the Luxembourg and the Louvre, in the heart of the artists' quarter. Not far from where he lived was the Café du Dôme which he frequented and which, in passing, is still there. The Dôme was a meeting place for artists during this time, mostly Americans and Germans.[7] The Germans were chiefly followers of Matisse: Hans Purrmann, Rudolph Grossman, Oscar Moll, Rudolph Levy, and William Uhde. In 1906,

Lyonel Feininger visited the Dôme during his stay in Paris. In addition, at various times Augustus John, Jacob Epstein, and Jules Pascin joined the group there. Across the street, in the equally famous Café la Rotunde, on a given evening a visitor might find Picasso, Derain, Vlaminck, and, rarely, Braque.

Whether or not Marin was touched by all he saw and experienced of French modernism at the time he was in Europe is open to argument. In 1922, Marin would say no more than, "4 years abroad. Played some billiards, incidentally knocked out some batches of etchings which people rave over everywhere."

Marin was very much involved in etching while in Europe. However, this concern with etching, for which he had a market, did not keep him from drawing and painting. "I want to get these etchings out of the way," he wrote his father from Amsterdam in 1906, "so that I can tickle up some of the paintings I made at the seashore" (unpublished letter owned by Mr. and Mrs. John Marin, Jr.).

The drawings of this period, like the paintings, were without an established market and this may be why they, rather than the prints, seem the vehicle of more advanced stylistic traits. The changes that occurred after 1905 can be seen by comparing two ink drawings—**The Harbor** (1898) (Catalog no. 4) and a **Dock Scene** (1906) (Catalog no. 15). The later drawing shows considerable advance in terms of a broader, more vigorous approach to the subject. Soft lyricism gives way to masculine directness. Yet, that this drawing

neither represents a break in Marin's work nor is even unknown, in type, earlier can easily be demonstrated. **Central Park Lagoon and Buildings** (Catalog no. 14) was done in 1905, probably shortly before Marin embarked for Europe. It shows the spirit of liveliness of observation connected with the 1906 **Dock Scene**. On the other hand, **London—The Thames** (Catalog no. 16), most likely executed in 1906, represents the veiled, misty view of the world often found in Marin's art before 1905.

A truly remarkable little drawing, which completely shatters any lingering nineteenth-century conventions of style, is the one inscribed "Paris, Sept. 23/10." Here (Catalog no. 18) introspective poeticism yields to concentration, tenseness, and brittleness. Set against any of the earlier drawings, we see clearly that Marin is pulling toward a more positive Expressionist art.

It was probably toward the end of 1908 that Marin met Edward Steichen in Paris.[8] This meeting was decisive for Marin because through it he came in contact with Alfred Stieglitz. The story of the friendship between Marin and Stieglitz is well known, and it endured until the death of the photographer in 1946.

Marin said: "The doors have been swung wide open to me by my friend, Alfred Stieglitz." At the Photo-Secession Gallery, 291 Fifth Avenue, New York City, Marin saw works by Cézanne, Matisse, Braque, Picasso; he saw the efforts of Weber, Dove, Mauer, and Hartley; he witnessed exhibitions of African art and children's pictures hung as art.[9] It was here, too, that Picabia and Duchamp came when in the United States. In this hothouse atmosphere of avant-garde experimentation, Marin produced, during the winter of 1912–13, among the most advanced works being done by any American on this side of the Atlantic.

The pictures that mark Marin's full entrance into the foreground of modernism are his views of New York City. He had depicted views of the city at least as early as 1910. There are a number of watercolors extant, signed and dated by Marin 1910 (done, most likely, during a brief trip home from Europe), of the East River spanned by the Brooklyn Bridge. The pencil drawing in this exhibition of this same subject (Catalog no. 19) was likely done about the time of the paintings, or about 1910. It is a skillful, but not exciting, rendition of the scene. However, by the winter of 1912–13, he had arrived at a startlingly new and daring interpretation of the theme of the city (see Catalog nos. 23 and 24). When Marin first showed his watercolor versions of these themes, he was fully aware of their daring unconventionality, and he included in the catalog of the 1913 "291" exhibition the often quoted statement for those "who may be in need of an explanation."[10]

In this statement Marin made a number of important points. For one, he recorded his acceptance of the fact that art must reach beyond representation; the artist must not be hindered by a "photographic" viewpoint. (Here he probably owes a debt to Stieglitz's concern for an anti-painting photography and an anti-photographic painting.) In this context Marin's view of the necessity for the artist's release from dealing with externals can be interestingly compared with that of Francis Picabia in a foreword to the catalog of his own first exhibition at "291" immediately following Marin's: "The qualitative conception of reality can no longer be expressed in a purely visual or optical manner; and in

consequence pictorial expression has had to eliminate more and more objective formulae from its convention in order to relate itself to the qualitative conception."[11]

Marin's writing style, like his pictures, lacks the mechanical tone, the metallic rationality of Picabia's. In a more intuitive way, however, Marin was insisting that his New York pictures represented a search for a language in tune with his emotional reactions to the city: "It is this 'moving of me' that I try to express, so that I may recall the spell I have been under and behold the expression of the different emotions that have been called into being."

The renditions of New York beginning in 1912 and represented here by the drawings seem closely related to two styles current in Europe at that time: Futurism and Orphism.

In a sense, Marin's catalog statement related him most closely to the Futurists. He admitted that he was interested in portraying not simply what he saw in the city from the old naturalistic point of view but the interior forces he sensed were at work "pushing, pulling, sideways, downwards, upwards." The year before, 1912, the Futurist painters proclaimed "We have declared in our manifesto that what must be rendered is the <u>dynamic sensation</u>, that is to say, the particular rhythm of each object, its inclination, its movement, or, to put it more exactly, its interior force."[12] Marin wrote, "I see great forces at work; great movements; the large buildings and the small; influences of one mass on another greater or smaller mass." The Futurists said: "Every object reveals itself by its lines how it would resolve itself were it to follow the tendencies of its forces Furthermore,

every object influences its neighbors . . . by a real competition of lines and by real conflict of planes, following the emotional law which governs the picture."

In paintings, prints, and drawings of the period, Marin often captured a quality of movement surging in a given direction by spilling the contours out to echo the form. It might be said that some of his objects and people look as if they had been photographed at a speed too slow to freeze the action. This idea, the concept of the shifting and changing relationship of forms in motion, was verbalized in the Futurist Manifesto of April, 1910: "The sixteen people around you in a tram are successively one, ten, four, three. They hold still momentarily, but then shift again, coming and going with the swaying tram . . . persistent symbols of universal motion."

Stylistically, however, Marin's pictures resemble more the Orphist work of Robert Delaunay than the Futurists'. The renditions of the Brooklyn Bridge (Catalog nos. 22 and 23), for example, relate to Delaunay's various interiors of St. Severin. Marin's treatment of the tower-like Woolworth Building has a similar connection with Delaunay's several Eiffel Tower pictures of about 1910 (Catalog no. 15).

How Marin could have come in contact with such ideas and examples may possibly be explained by the close connection of "291" with avant-garde artists abroad. Marsden Hartley was in Europe the spring of 1912 and he might have sent back a copy of the catalog of the famous Futurist exhibition of that year. Closer to home, the New York **Sun**, February 25, 1912, reproduced the 1910 Futurist Manifesto; the March 23, 1912, issue of **The Literary Digest** carried an illustrated essay on Futurism containing long quotations from the 1912 exhibition catalog. The fact that Marin's watercolors of such subjects often tend toward a bluish, monochromatic

palette, may suggest the visual source was a photograph. Whatever the origin, the pictures dating back to 1912, including the drawings, demonstrate that Marin, rather than Joseph Stella, was the first American to set forth Futurist concepts in his art.

Cubism, also, played an important role in Marin's artistic evolution. During the period he was in Europe, 1905–11, he appeared not to be aware of or interested in Cubism. However, beginning about 1913 and reaching a noticeable peak about 1915–16, Cubist elements become clearly identifiable in his work.

The sources of the Cubist influences are not difficult to find: In 1911 Stieglitz purchased a very fine Picasso drawing (now in the Metropolitan Museum of Art), which Marin seems to have been quite familiar with; the Cubists were prominently displayed in the 1913 Armory Show; in 1914 Braque and Picasso were shown at "291." In any case, Marin's use of Cubist elements relates to the Synthetic rather than the Analytic phase of the movement, e.g., **Grain Elevators**, ca. 1916 (Catalog no. 31).

The degree of geometric abstraction in this drawing of about 1916 done at the grain elevators around the docks of Weehawken, New Jersey, as well as relating it to Cubism, also shows how close Marin came to a nonobjective art. (This drawing, by the way, is connected with a group of etchings of the same subject, executed between 1916 and 1917). He did move completely into a nonobjective art in a number of experimental watercolors done in 1917, but his attention was not held by such possibilities: "Oh Hell. Nature's

arrangements are much finer, more, infinitely finer than your studio arrangements, my fine studio arrangements." Even when he was deeply engaged in a highly constructed ("studio arrangements") art, as in many works of the twenties, he harbored a basic suspicion of such procedures.

The potential range of Marin's connection with or alienation from a representational view of nature can be illustrated in various drawings of the Weehawken dock area. One, done about 1912 (Catalog no. 20), is a relatively straightforward view of the scene. The artist could not resist certain small alterations, e.g., the subtle bending of the grain elevator itself. Nevertheless, the overall impact of the drawing is one of correct representation. Throughout his career, Marin made many drawings which appear to have no other purpose than to capture the general appearance of a place. These drawings, many of them, were like exercises, scales on the piano, to keep his hand and eye in practice.

The drawing of the same general scene (Catalog no. 29), done about 1915, demonstrates the next stage away from dependence on what is there to be seen objectively. In this drawing there is an increase in the sense of movement through deliberate manipulation of arrangement and distortion of parts: The railroad yard in the foreground has become a series of diagonal lines and rectangular shapes echoed across the river by the New York skyline; the grain elevator is distorted to a point where it appears to dance to an unheard angular rhythm; the whole composition is imbued by movement up, across, and into the picture; the dynamic structure of the whole spills out into the sky which becomes a field of nervous parallel pencil strokes.

There is, in this drawing, a definite sense of rectilinear organization around vertical and horizontal axes. This arrangement probably owes to Cubist sources, but the rest-

lessness of the entire composition relates it to the series of New York pictures begun in 1912. By contrast, the already mentioned (Catalog no. 31) rendition of the subject of approximately 1916 seems effete and diminished by a self-conscious concern with picture making. Marin's imagination seems, in my opinion, most effective when working out a solution linked to reality but not limited by that link to rendering only what's there.

The Photo-Secession Gallery closed its doors in 1917. In 1912 Marin had married, and in 1914 his only child, John Marin, Jr., was born. In 1914, too, he discovered Maine. The attraction to that state was immediate, and he described his fascination in a letter to Stieglitz: "This is one fierce, relentless, cruel, beautiful, fascinating, hellish, and all other ish'es place."

The demise of "291" did not mean the end, or even the lessening of Marin's relationship with Stieglitz. The great photographer arranged shows for Marin in the galleries of congenial New York dealers Montross and Daniel. In 1925 Stieglitz opened his own gallery once more, the Intimate Gallery, which was succeeded in 1929 by the famous An American Place. Rather amazingly, Marin, once he was connected with Stieglitz, never had to do anything but paint, etch, and draw for his livelihood.

By 1920, Marin had reached a point of maturity in his work which makes the discussion of influences rather mean-ingless. To use Oliver Larkin's happy phrase: "In Marin's watercolors of the twenties his mind dictated nothing which his hand could not do."[13]

In terms of subject, Marin's art divides into two major categories: landscape and cityscape. This would not be worth noting if it were not also evident that his approach to the two appears also to divide: landscapes done in a free expressive style; cityscapes shaped into a more discernible geometric structure. Like all generalizations, there are notable exceptions. The drawing called **New York from Dyckman Street Ferry Hill** (Catalog no. 34), done about 1921 and closely related to a well-known watercolor titled **Sunset**, shows a geometricizing of parts as if the artist had gone back over one rendition of the view, imposing another, more angular, interpretation. The result, not unusual in Marin's work, is a balance fragilely held—all parts of the picture appear to be struggling for release from the delicate equi-librium holding them in check. As a work of art, the picture is energized by a vision many times more powerful than those of the earlier drawings discussed.

In truth, however, a broad knowledge of Marin's art reveals that this landscape is more closely connected with city views of the twenties than the majority of the pictures of the countryside. (**New York from Dyckman Street** is really a landscape, city scenes being mainly of buildings.) The draw-ings of the **New York Stock Exchange** and **Downtown New York** (Catalog nos. 35 and 37) offer the only major parallels to the landscape analyzed above.

Conversely, the fluidity of **White Mountains, New Hampshire** and **Taos Mountains** (Catalog nos. 36 and 47) illustrates how free most of Marin's landscapes of the twenties are from the geometry of the cityscapes.

Another side of Marin's experiments with geometric structure, not represented in the drawings included in this exhibition, was the development of very formal compositions. In fact, when Marin began to exhibit some of these in the early twenties, they appeared, to many observers, the most significantly new tack in his art. For example, Thomas Craven, looking at such pictures, supposed that Marin had been "counseled or instigated by his admirers to try his hand at intellectual design."[14] Craven did not like what appeared to him as an arbitrary geometric division of the picture surface. On the other hand, Forbes Watson wrote, "After so many years of emotional painting, and after such a vast production, it is not to be expected that a man can continue to rely too exclusively upon temperament."[15]

That such debate was, in a sense, irrelevant is not only proved by the mass of paintings and drawings of the twenties, but also by those of the thirties. In the thirties Marin created some exceedingly dynamic renditions of New York. The group, for example, in the Metropolitan Museum (Catalog nos. 57, 58, 59 and 60), or the **At the Battery** (Catalog no. 48), are cases in point. These drawings have become even more complicated in their angularity than the drawings of the twenties. In particular, Marin now loves to emphasize the step-like structure of the skyscrapers, elaborating the theme by echoing the steps into the space around the buildings (he evolved this idea into a number of important oil paintings during this decade).

He returned to the motif of the Brooklyn Bridge during this time (Catalog nos. 50 and 51). Actually, he never left it; the bridge recurs throughout his work (see Catalog nos. 28 and 45). But in these two drawings of about 1931 (related to etchings done that year), he goes back to the series of approximately 1913—also related to a group of etchings (Catalog nos. 22, 23, 25 and 26). Comparing the two, the tightening into a tenser angularity in the later pictures becomes apparent.

Earlier it was remarked that Marin was not particularly inclined toward figurative art. There are exceptions—a few interesting sketches done in ink during his student days (not included in this exhibition). From the first, he was a landscapist, interested in capturing the moods of nature. Figures, when they appear, are usually barely distinguishable from their surroundings. By 1929, Waldo Frank found this fact a deliberate and revealing aspect of Marin's art.

> John Marin has found the human world dark and unwieldy. But there is light in trees, in fences, in mounds of earth, in the glance of sun on sails: and from this he has made the grammar of his soul. The common details of his landscapes are revealed like common words in a lyric. What they express is ample for us, precisely because they articulate his refusal to form his beauty from the world of men.[16]

Almost as soon as Frank had written the above, Marin became very interested in the human figure. In fact, along with the appearance of large numbers of thickly painted oils, the most distinctive trait of the thirties is the figure pieces that were produced.

The figure drawings of the thirties in this exhibition (Catalog nos. 55 and 63), cover a range which extends from fairly direct observation of life to highly involved themes. Those that

represent direct observation, e.g., **Three Seated Figures** and **Grouping of Figures** (Catalog nos. 56 and 62), reveal the artist's ability to capture the essence of the group in a very few deftly articulated strokes of the pencil. Where he seems, in my opinion, less successful, is in the transference of figures to more elaborate compositions. The chief distinction of **Seated Female Figure** (Catalog no. 63), for instance, is as decorative composition. The stylization of the human form may appear to border on the cute, or, to contemporary observers of the thirties reacting to similar pictures in oils, just silly. It's possible that Marin's intent, consciously or not, in concerning himself so specifically with figures during these years is as serious as the results seem frivolous. His friend Jerome Mellquist so expressed it in an unpublished article in 1934: "It is evident that he has been stirred in some way even beyond himself, and I suggest the sufferings of the people as being in part responsible. (Surely more human beings have figured in his work during the last two years than ever before.)"

Marin did not abandon the figure in the next decade. People play prominent roles in many of his circus pictures, e.g., **Trapeze Performers**, ca. 1945 (Catalog no. 75). However, the most remarkable use of the figure during the last years can be seen in the pencil drawing **Sea Fantasy** (Catalog no. 79). The nude woman rides the crest of a turbulent sea, like a classical personification of nature. The theme of union between the sea and the human figure haunted Marin, and he devoted a great deal of energy to such subjects in major paintings of the forties.

From the 1920s onward, Marin's reputation increased to national scale. By 1936 his position as one of the country's foremost artists was confirmed by the Museum of Modern Art's retrospective exhibition of his work. He soon found his role as living old master a little tiresome, and he rebelled at the thought of becoming curator of his own reputation.

> Yup—there is the Aged Marin—The Ancient Mariner a talking—the one who paints—the one who cannot paint anything other than masterpieces—
>
> I have discovered it—this perfection is getting to be damned tiresome—not to be able to make a mistake now and then—Cusses—more Cusses—doomed—to singing and praising forevermore by my own beautiful river—nuts—

The year Marin wrote these words, 1941, he was entering one of the most fruitful periods of his creative life, when he "surrendered himself to broadly lyrical impulses based . . . on rhythmic color phrase and accent."[17] The pulsating landscapes shown here—many in color—reflect such interests (Catalog no. 68), as do the late renditions of the circus.

The circus, a theme begun in the mid-thirties, illustrates the way Marin often stripped a subject of all but the barest essentials, and yet did not end with anything like a spirit of austerity. In the latest circus drawings (Catalog nos. 81 and 82), despite the economy of means employed, the artist communicates the richness of the visual idea of circus—the exciting rhythm and tempo of the motif. In their characteristics of simplicity and gaiety, they recall Alexander Calder's earlier bent-wire versions of the same subject.

It's interesting that so many of the late drawings are in color (Catalog nos. 68 and 74). One of the most striking features of his pictures in the forties and early fifties is the

quality of synthesis minimizing distinctions between media. Simply stated, at no other time in Marin's artistic life are his drawings and paintings so close in actual appearance as well as feeling.

Exhilaration and youthfulness exude from these last drawings. Who would guess that the energetic views of the city from New York Hospital (Catalog nos. 83 and 84) were executed at the time the artist was recovering from a serious illness? Age bore down upon him, but John Marin's spirit remained resilient to the end.

1. C. R. Morey, **Mediaeval Art** (New York, 1942), p. 6. Morey was discussing the ideas of Giovanni Morelli in regard to analysis of anonymous medieval works of art. The point made, however, is pertinent to almost any artist—that when most relaxed, caught off guard, so to speak, much is revealed about the artist that cannot be in a more self-conscious moment.

2. MacKinley Helm, **John Marin** (Boston, 1948), p. 5. All biographical references, unless otherwise stated, are taken from this source.

3. All quotations from Marin, unless otherwise stated, are taken from Dorothy Norman, **The Selected Writings of John Marin** (New York, 1949).

4. This evidence is in the form of letters in the possession of Mr. and Mrs. John Marin, Jr., New York City.

5. Mortimer Menpes, **Whistler as I Knew Him** (London, 1904), p. 20.

6. George Inness, Jr., **Life, Art and Letters of George Inness** (New York, 1917), p. 131.

7. See Charles Douglas, **Artist Quarter** (London, 1941), p. 141.

8. The usual date given for the meeting is 1909. See, for example, the chronology compiled by E. M. Benson in the catalog of the 1936 Museum of Modern Art retrospective exhibition (p. 36). However, since Marin's first exhibition at "291" was in March, 1909, there hardly seems enough time for them to have met, decided upon the exhibition, chosen the pictures, and then sent them off to New York. In a recent interview, Steichen told me he no longer remembers just when he and Marin met.

9. For a summary of exhibitions held at "291" see Waldo Frank et al., **America and Alfred Stieglitz** (New York, 1934), pp. 312–15.

10. Published first in **Camera Work**, nos. 42–43 (April–July, 1913): 18. Reprinted in its entirety in Norman, **Selected Writings of John Marin**, pp. 4–5; parts quoted in Helm, **John Marin**, pp. 28–29.

11. **Camera Work**, nos. 42–43 (April–July, 1913): 19–20.

12. From the catalog of the first Futurist exhibition to be held in London, at the Sackville Gallery, March, 1912. The show also went to cities in France and Germany. The full text is reprinted in Joshua C. Taylor, **Futurism** (New York, 1961), pp. 127–29.

13. **Art and Life in America** (New York, 1960), p. 387.

14. "John Marin," **The Nation** 118 (19 March, 1924): 321.

15. **The World**, Dec. 20., 1925.

16. **The Rediscovery of America**. Originally published serially in **The New Republic**, 1927–28. First published as a volume in 1929 Quoted here from **Rediscovery of America and Chart for Rough Waters** (New York, 1940), p. 137.

17. Sam Hunter, **Modern American Painting and Sculpture** (New York, 1959), p. 98.

SELECTED BIBLIOGRAPHY

Benson, E. M. **John Marin: The Man and His Work.** Washington, D.C.: American Federation of Arts, 1935.

Helm, MacKinley. **John Marin.** Boston: Pellegrini and Cudahy, 1948.

Helm, MacKinley and Sheldon Reich. **John Marin, 1870–1953.** Tucson: University of Arizona Art Gallery, 1963.

McBride, H., and E. M. Benson. **John Marin: Watercolors, Oil, Paintings, Etchings.** New York: Museum of Modern Art, 1936. Reprint. New York: Arno Press for the Museum of Modern Art, 1966.

Norman, D. **The Selected Writings of John Marin.** New York: Pellegrini and Cudahy, 1949.

Wight, F. S., and MacKinley Helm. **John Marin: A Retrospective Exhibition.** Boston: Institute of Modern Art, 1947.

Wight, F. S., et al. **John Marin.** Los Angeles and Berkeley: The University of California Press, 1956.

ILLUSTRATIONS

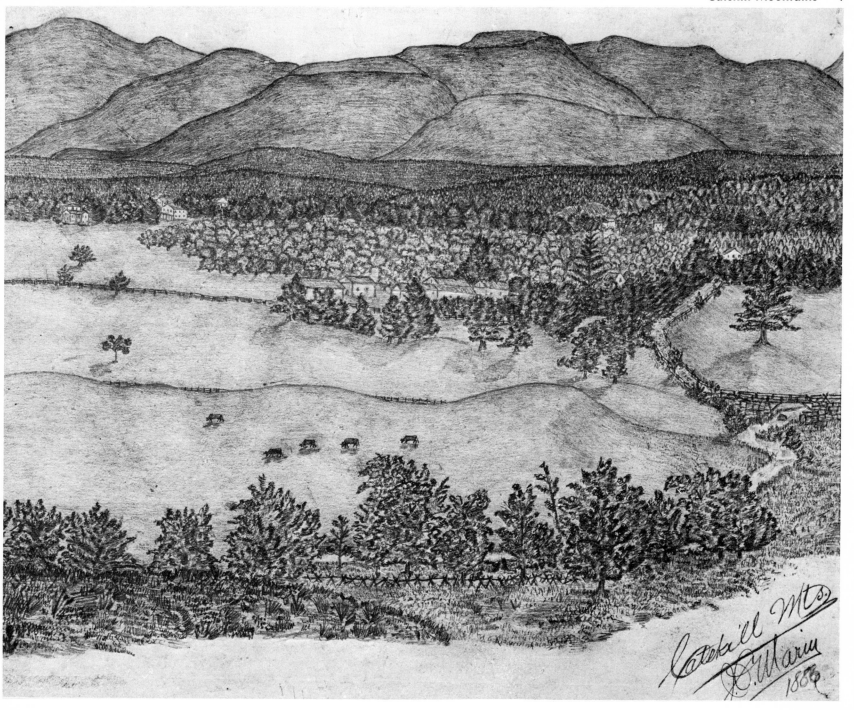

Catskill Mts.
J Marin
1888

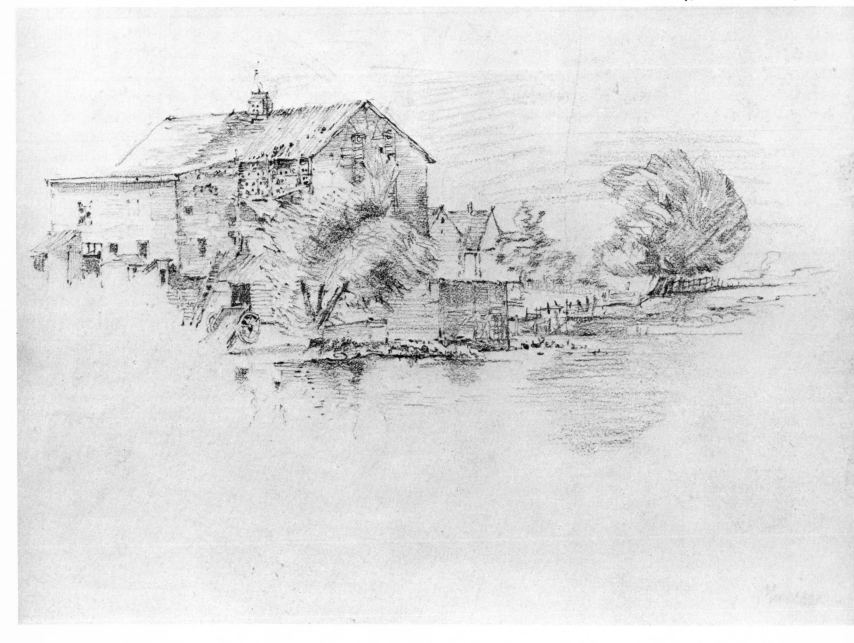

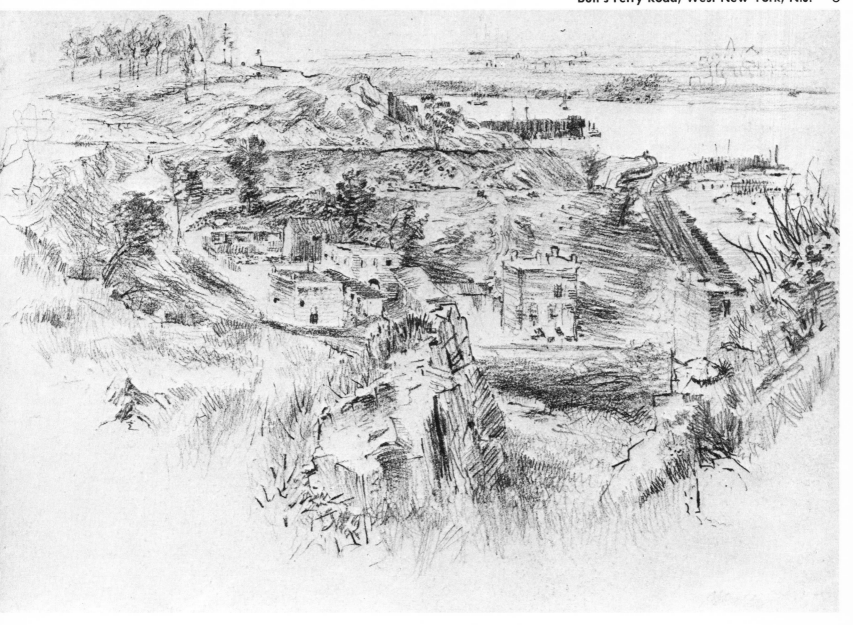

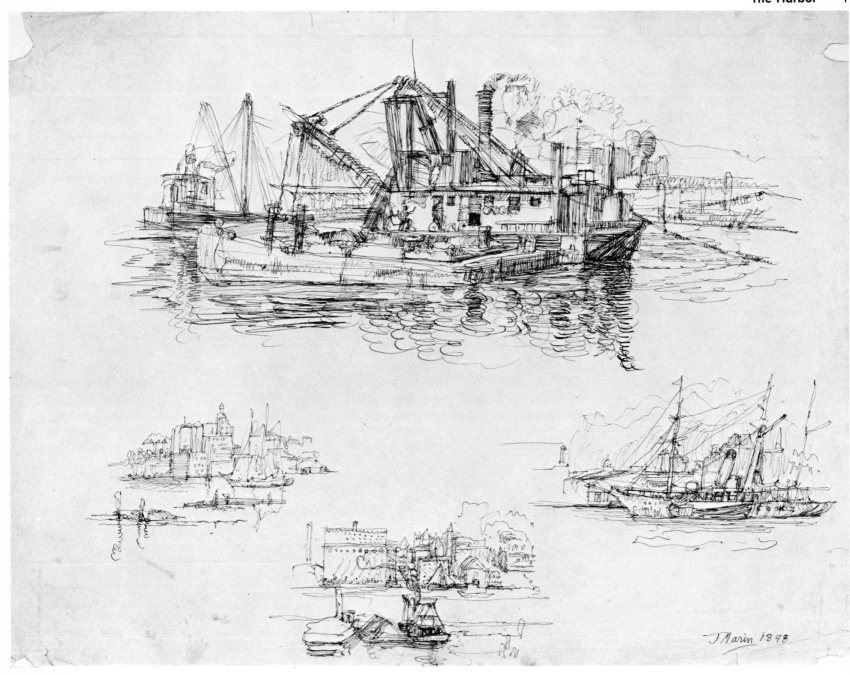

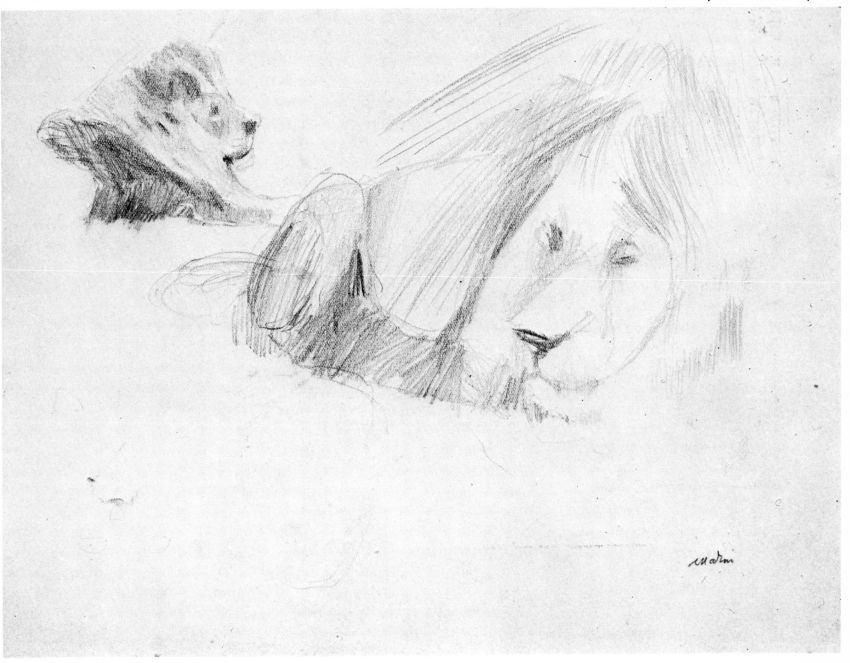

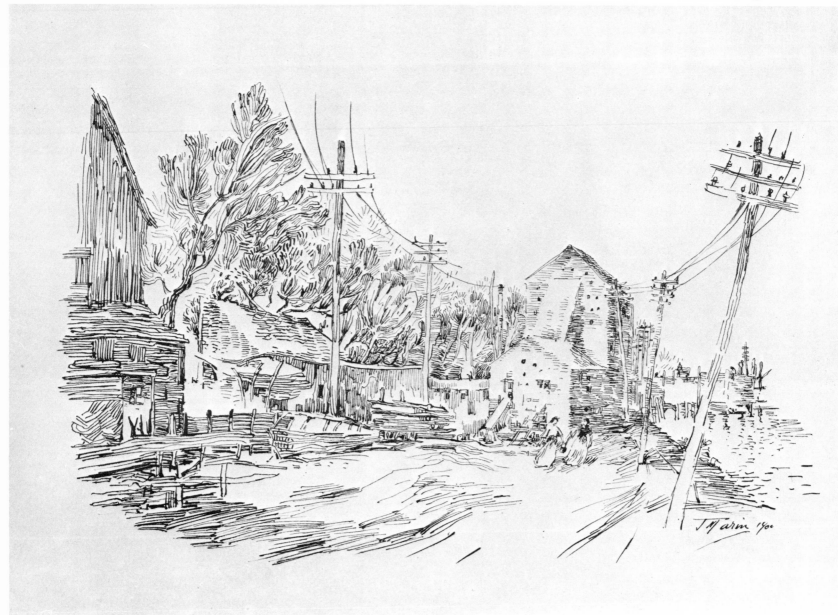

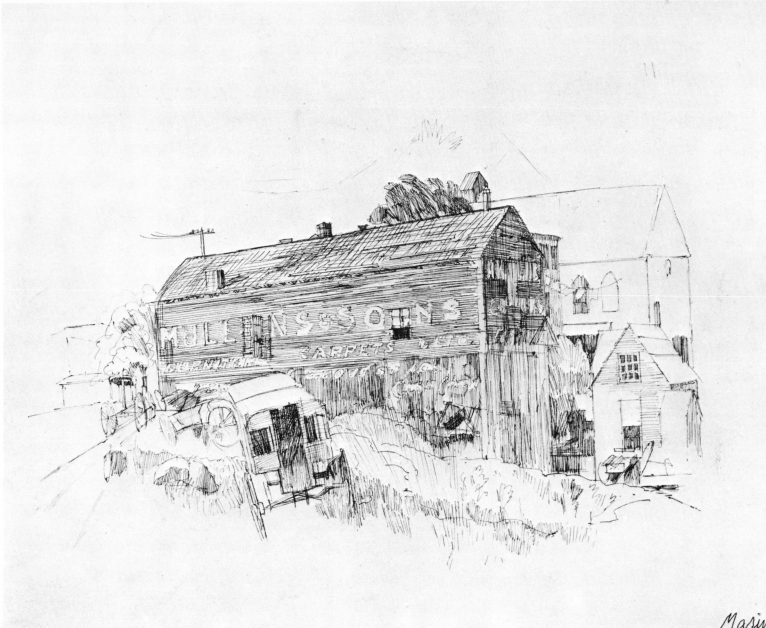

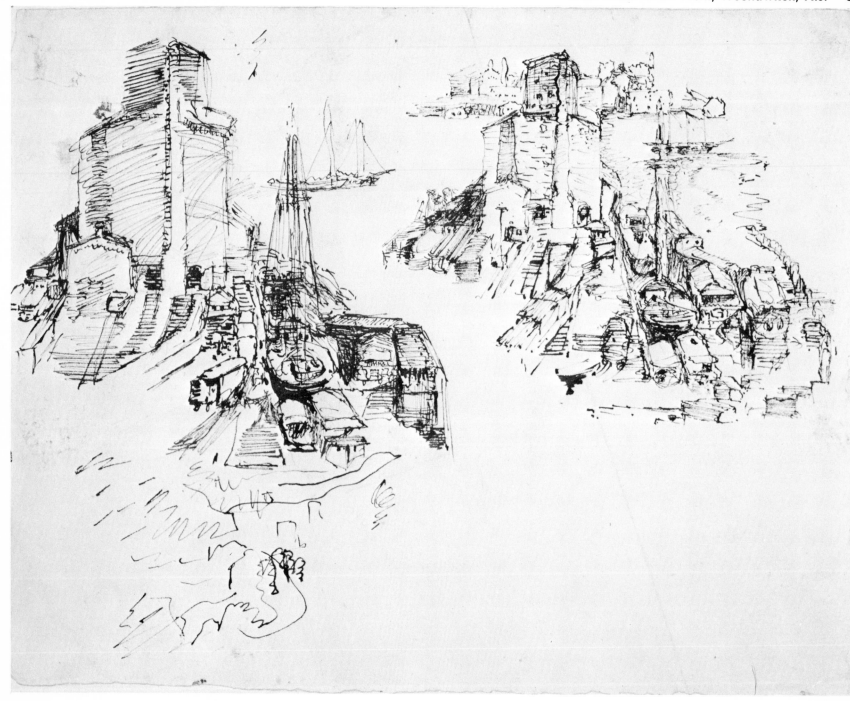

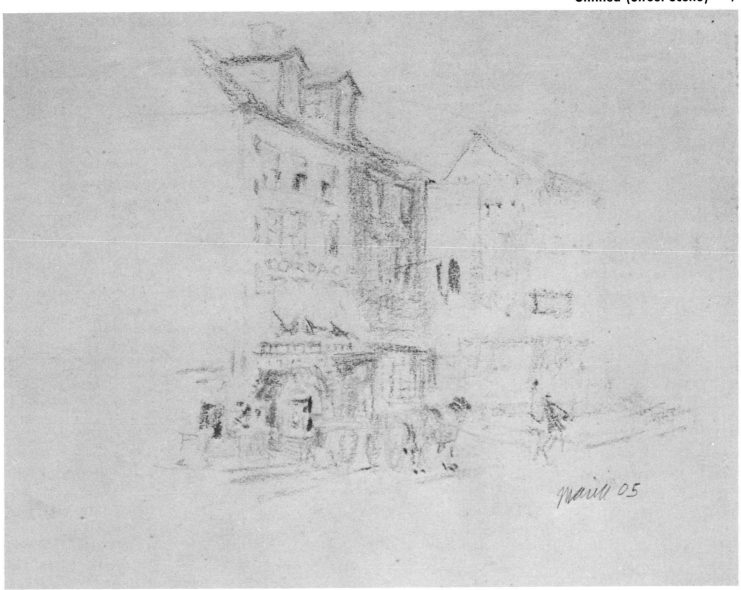

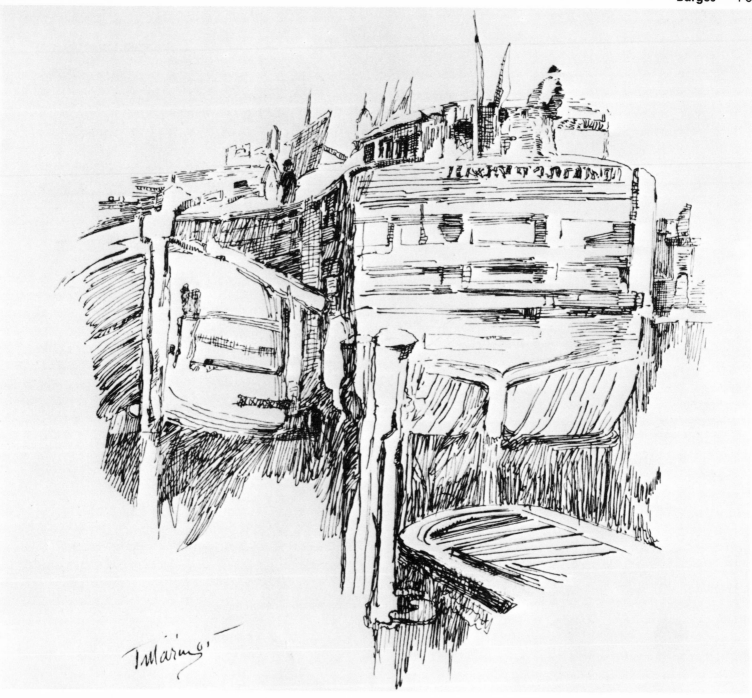

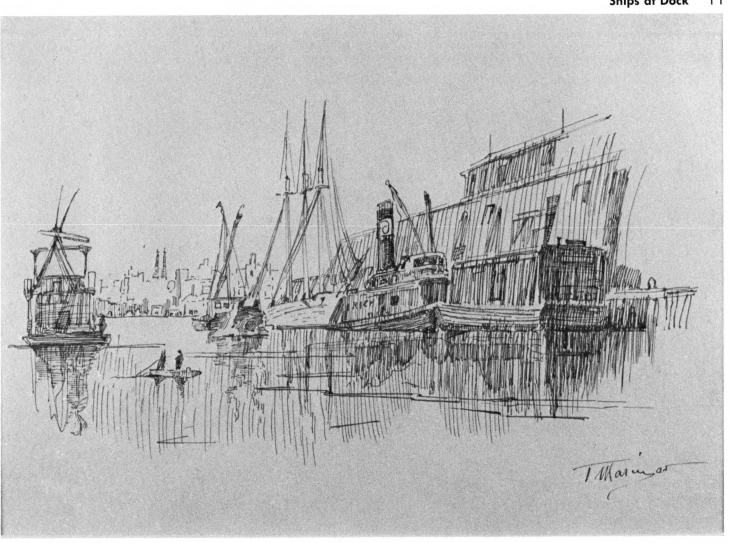

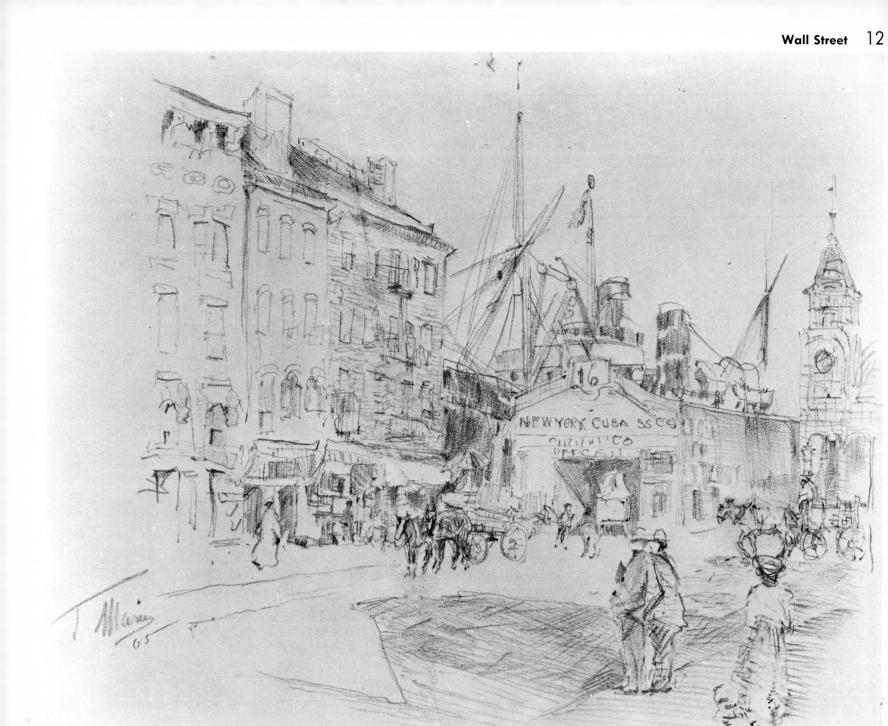

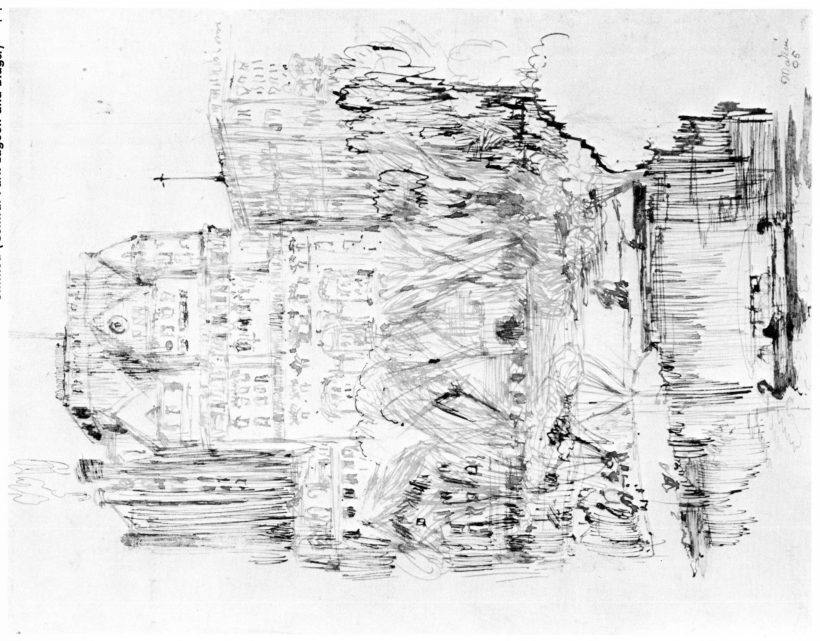

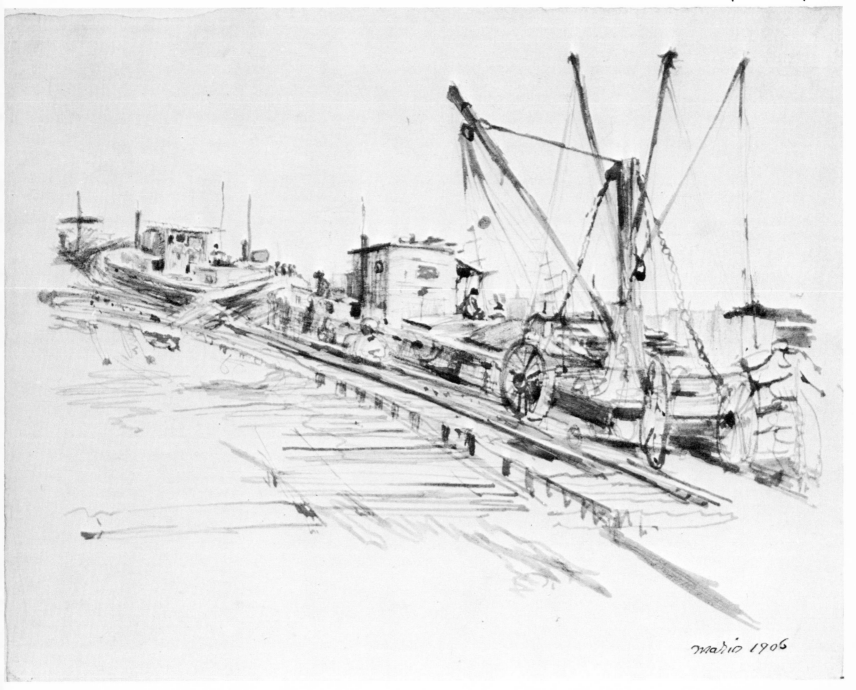

Mario 1906

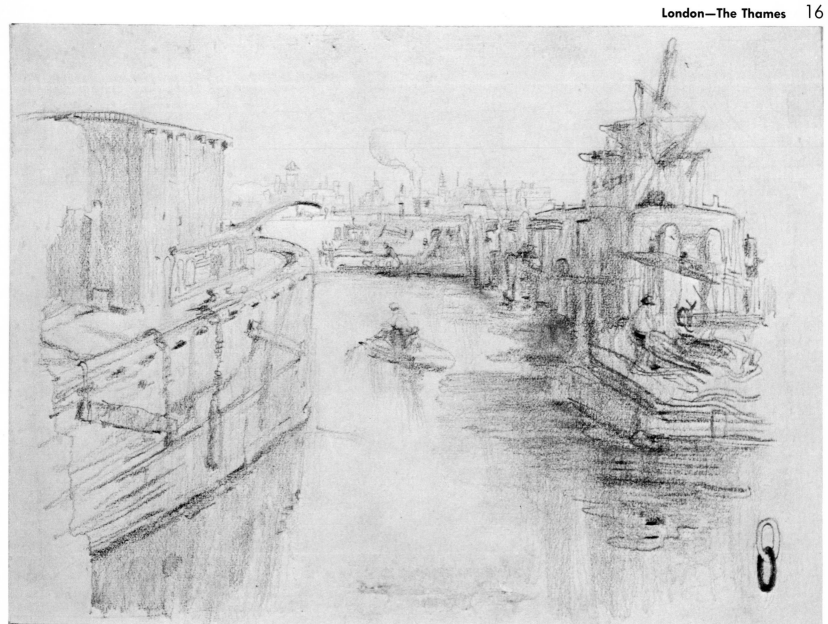

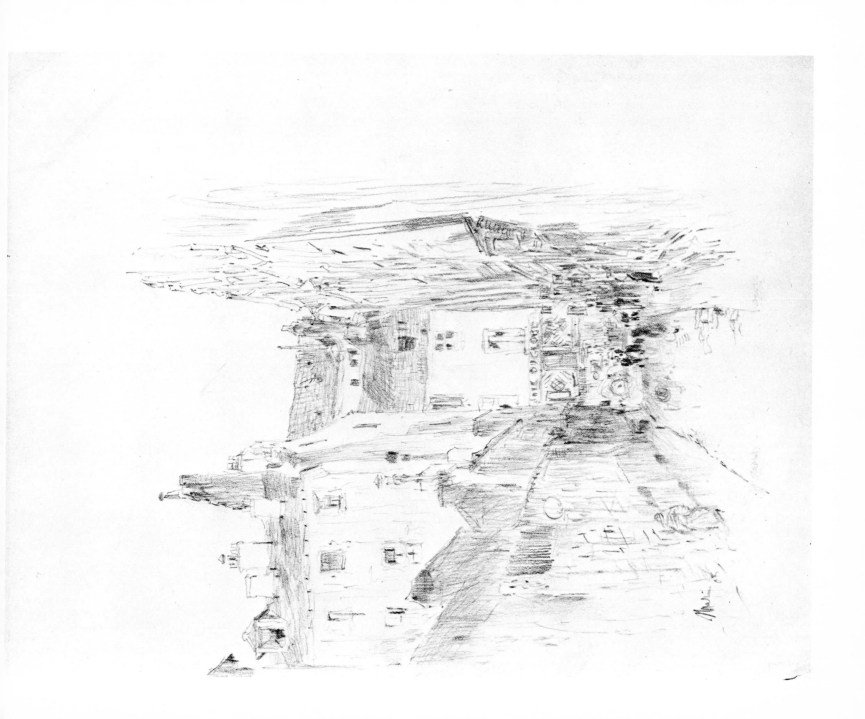

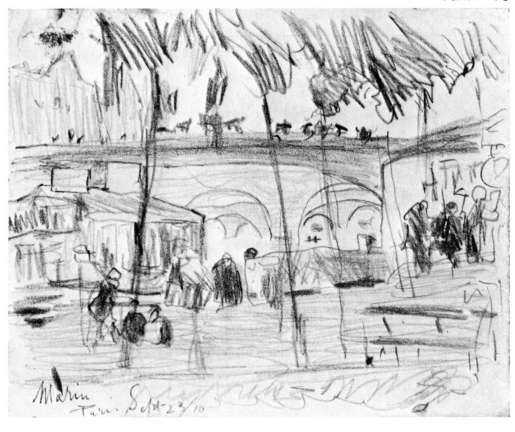

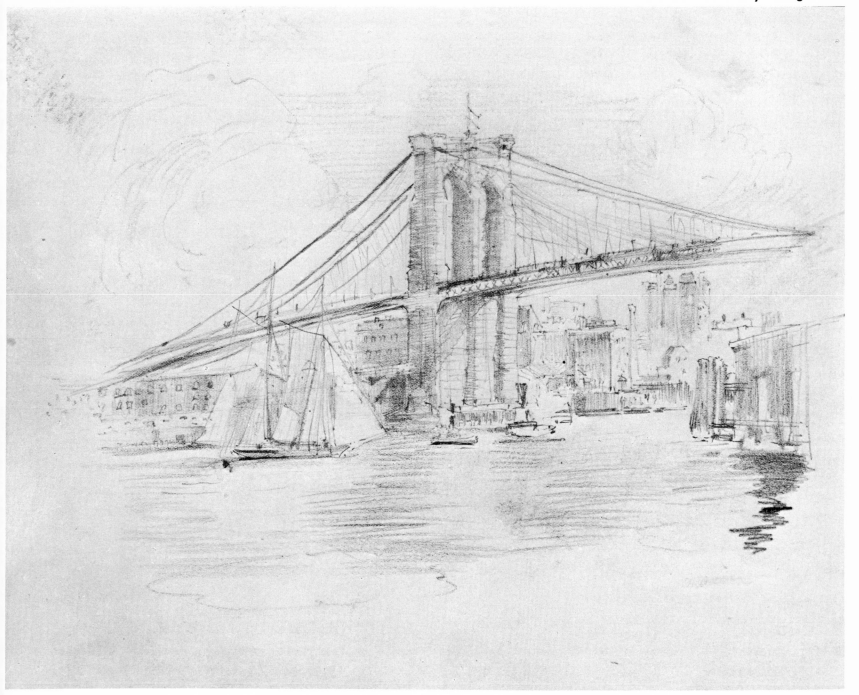

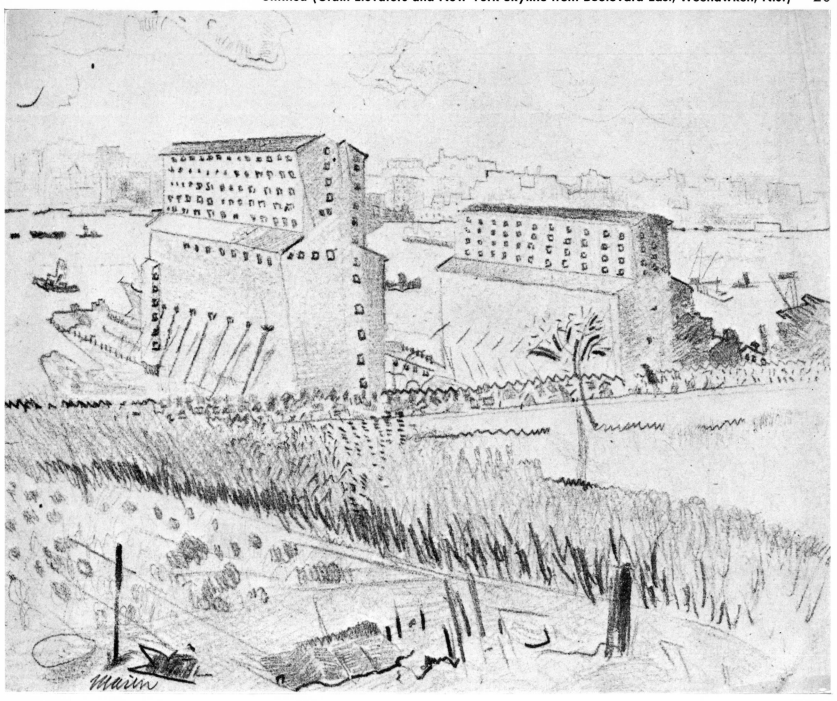

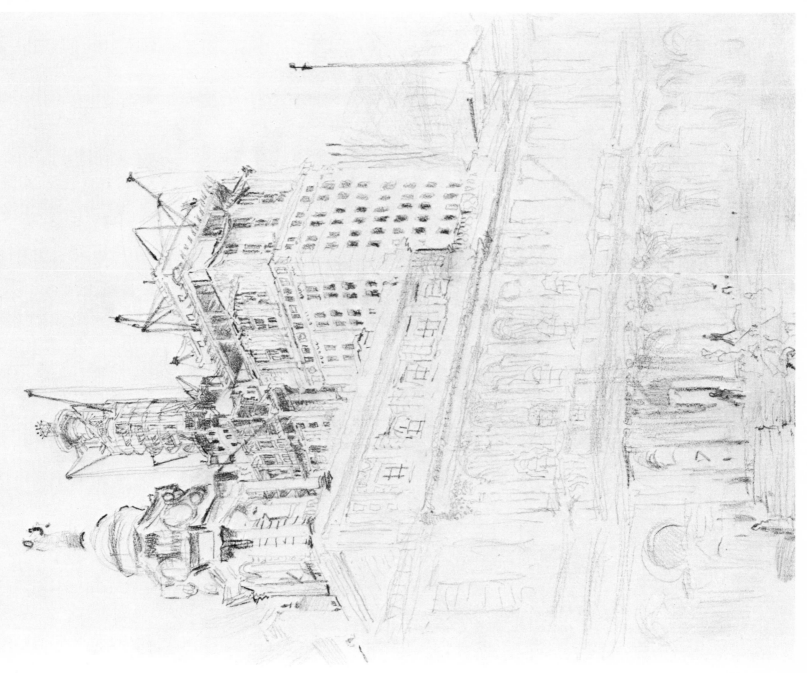

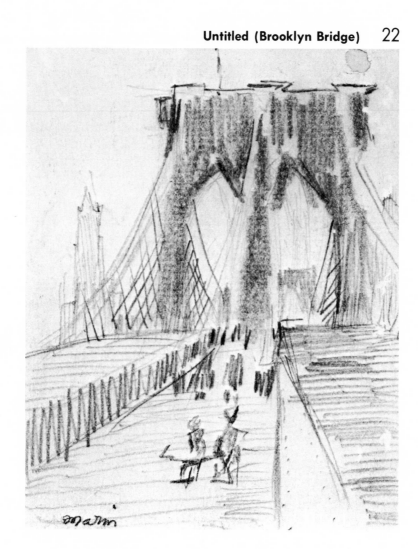

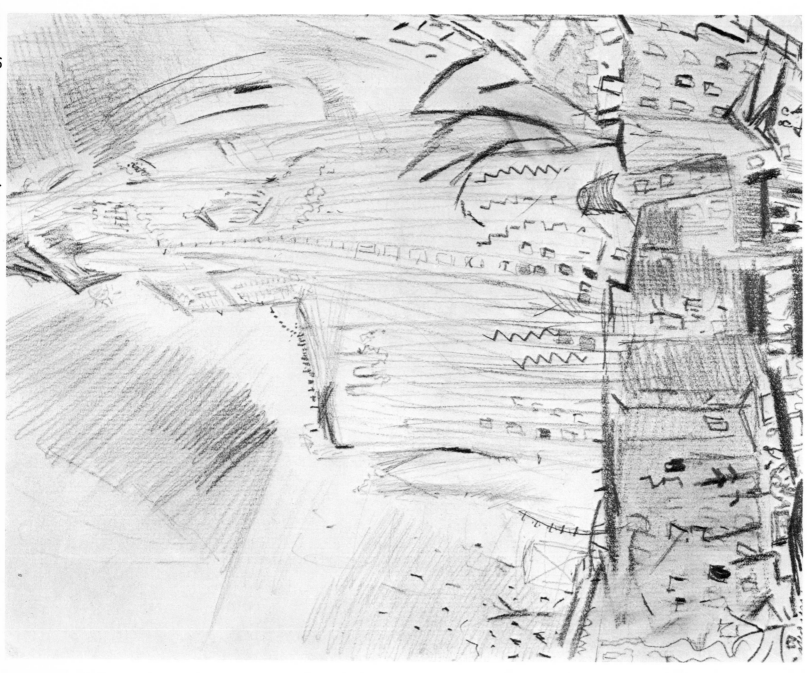

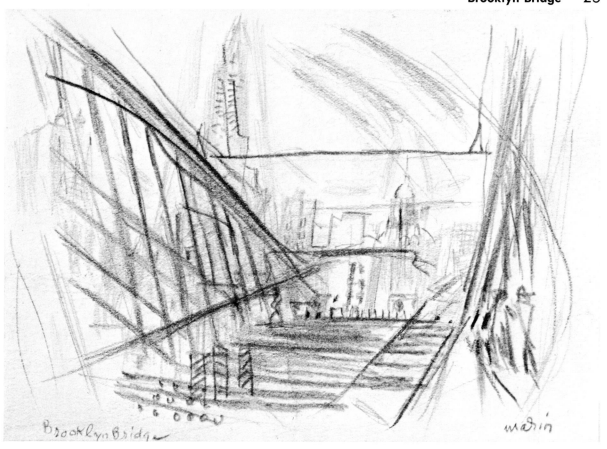

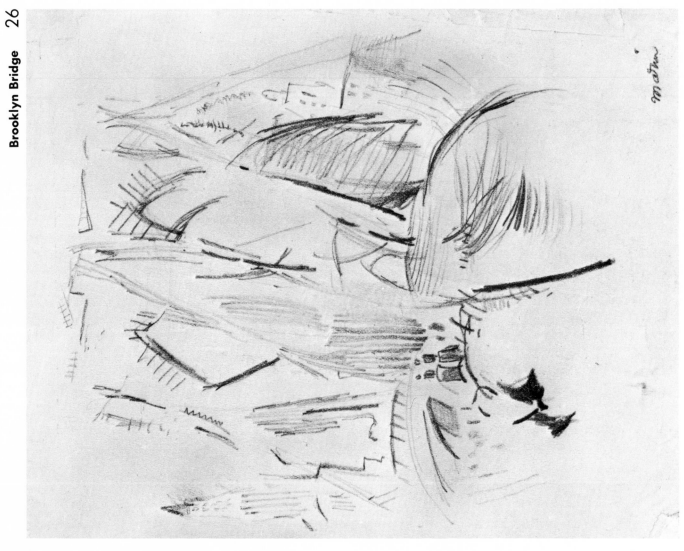

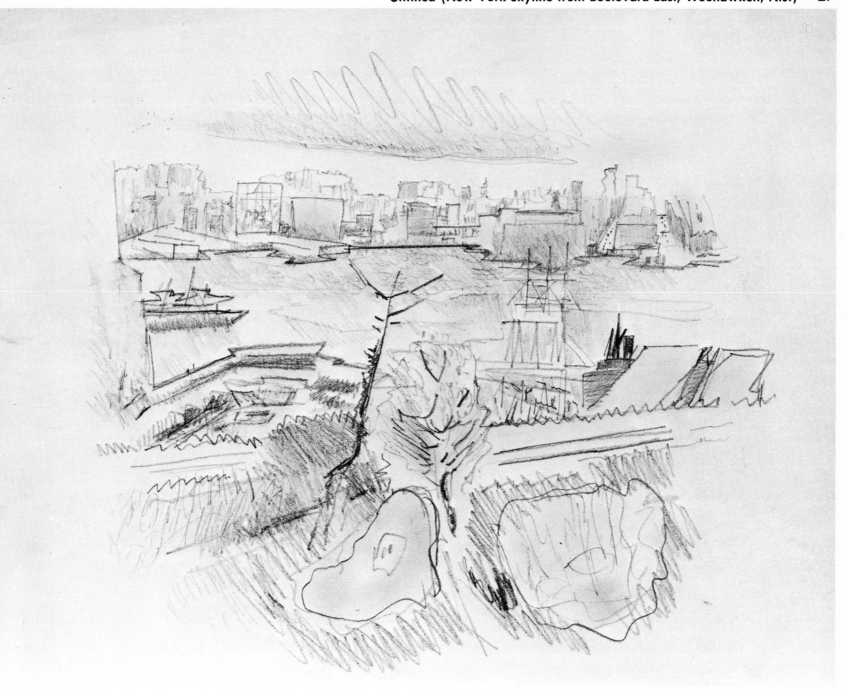

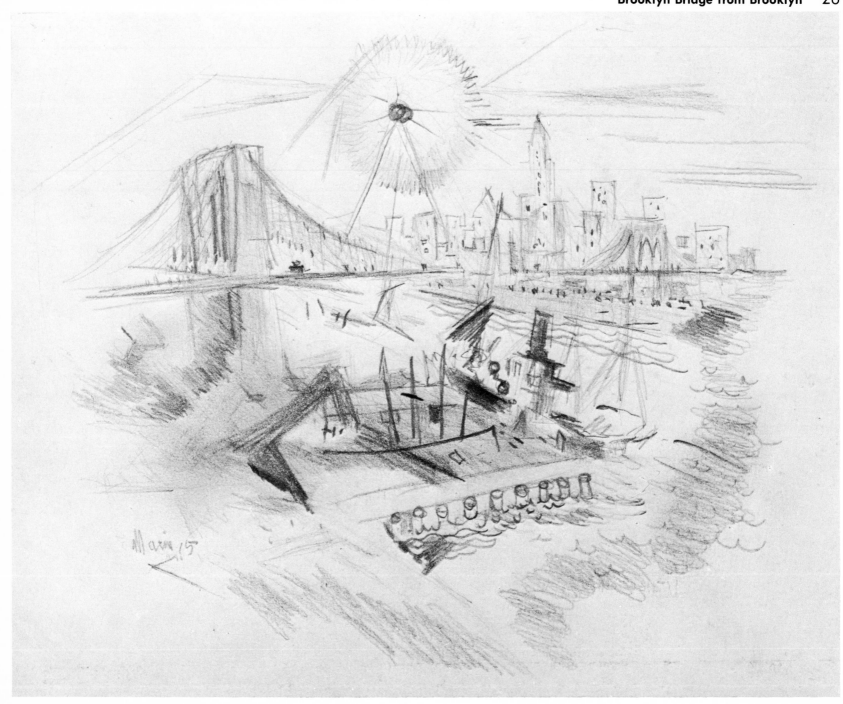

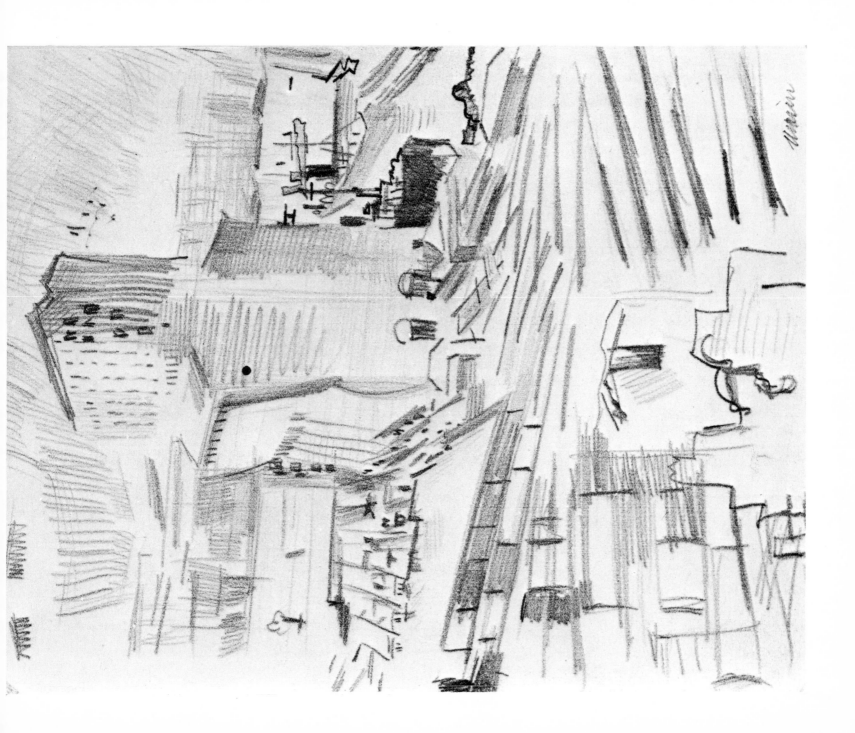

49

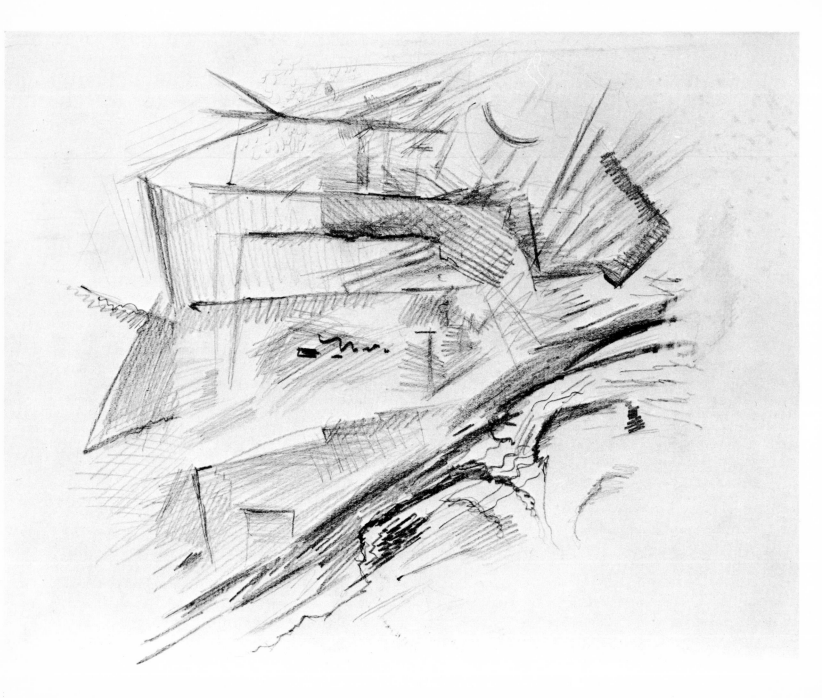

Untitled (Abstraction of Buildings and Natural Forms, Weehawken, N.J.)

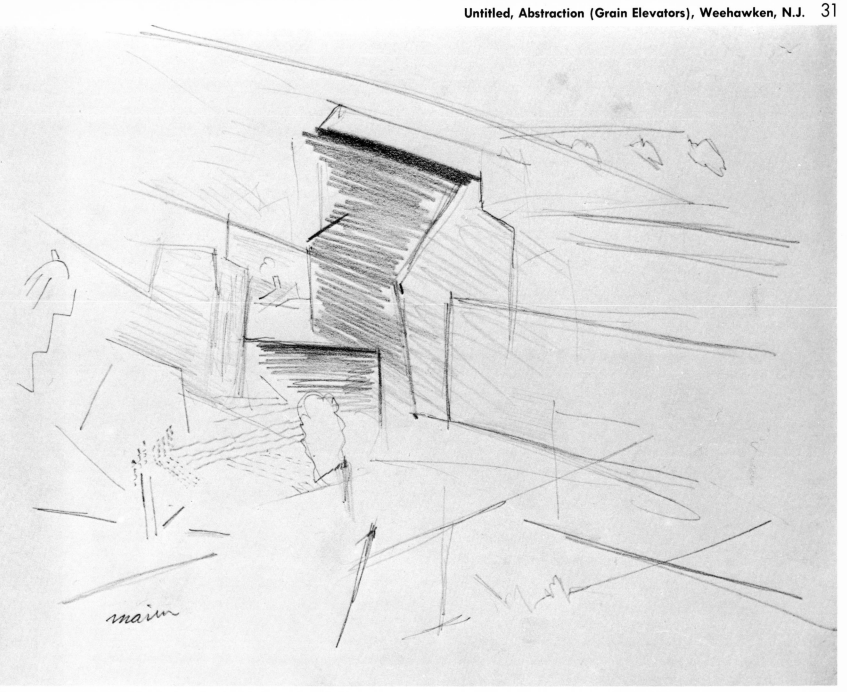

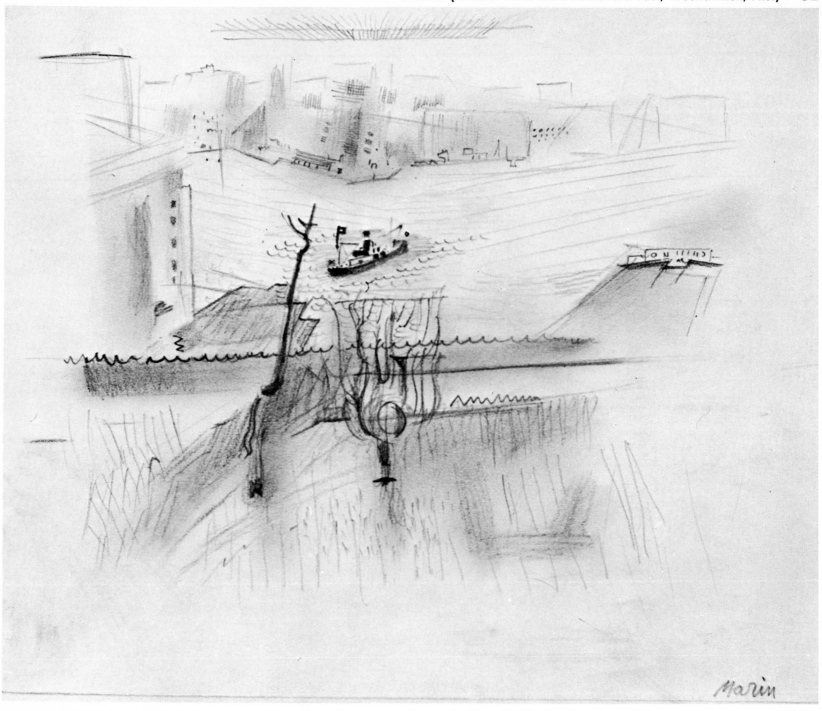

Marin

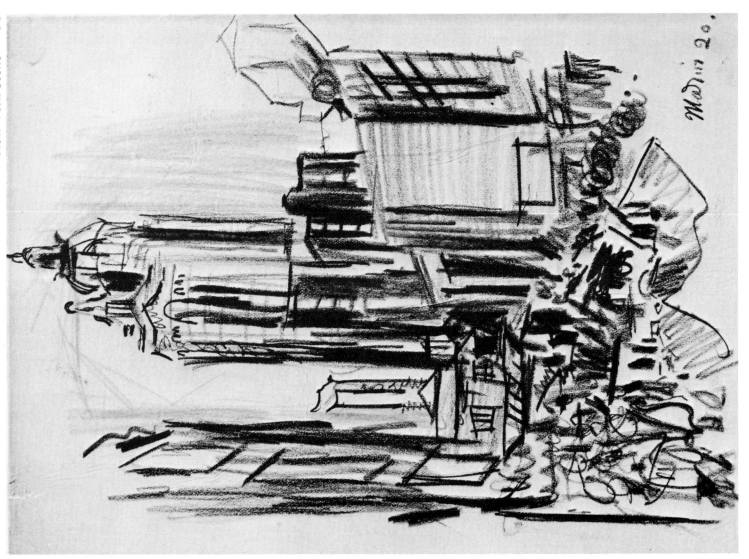

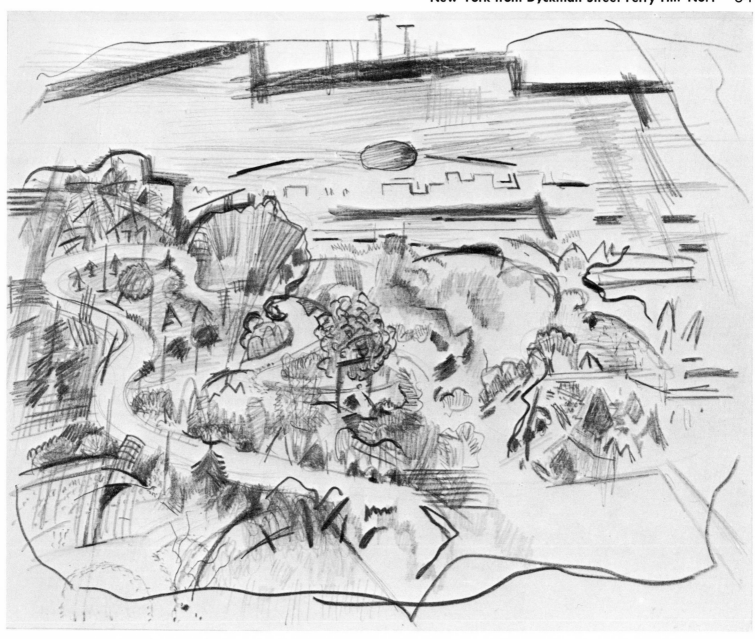

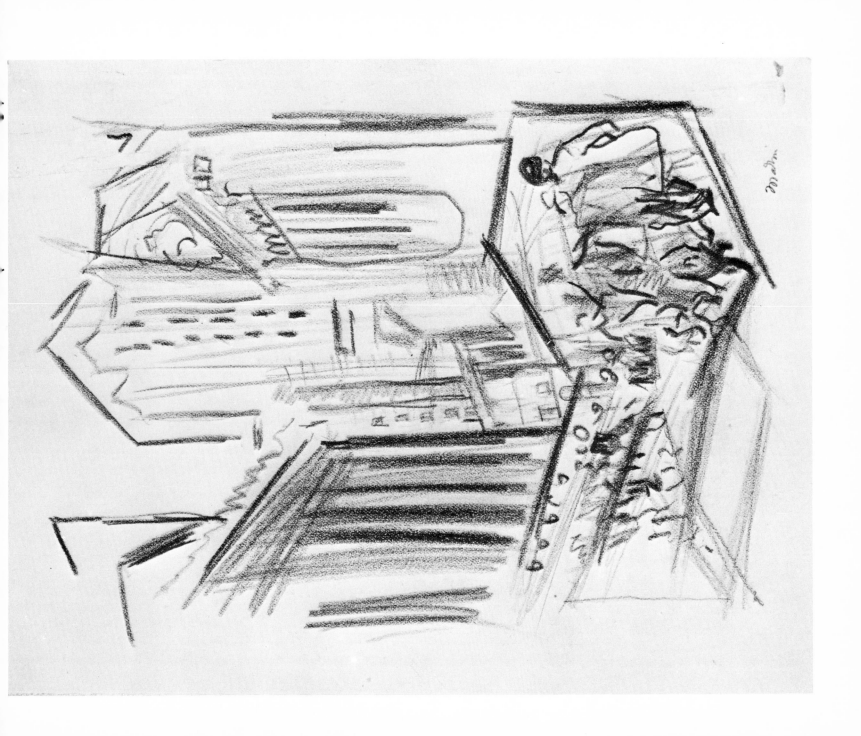

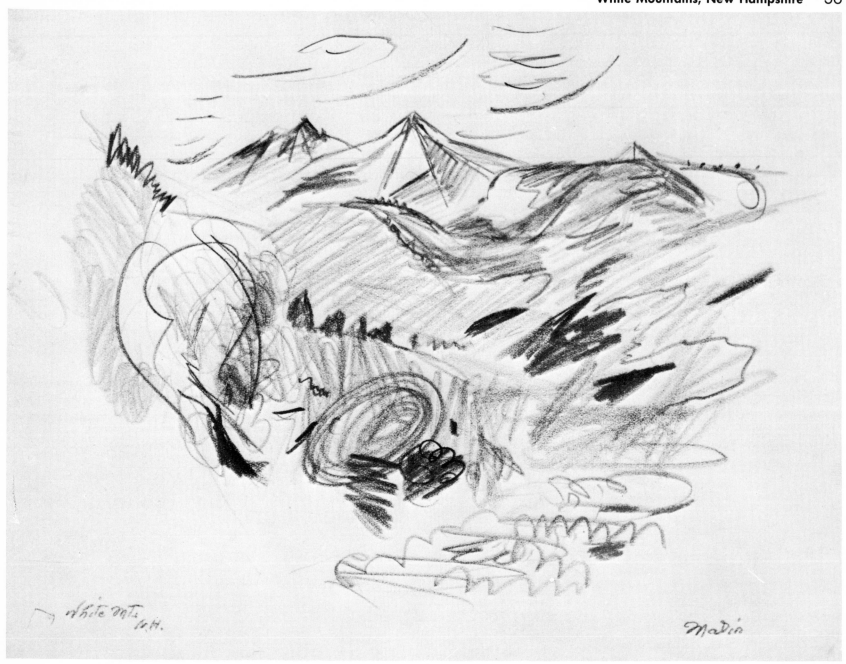

White Mts.
N.H.

Marin

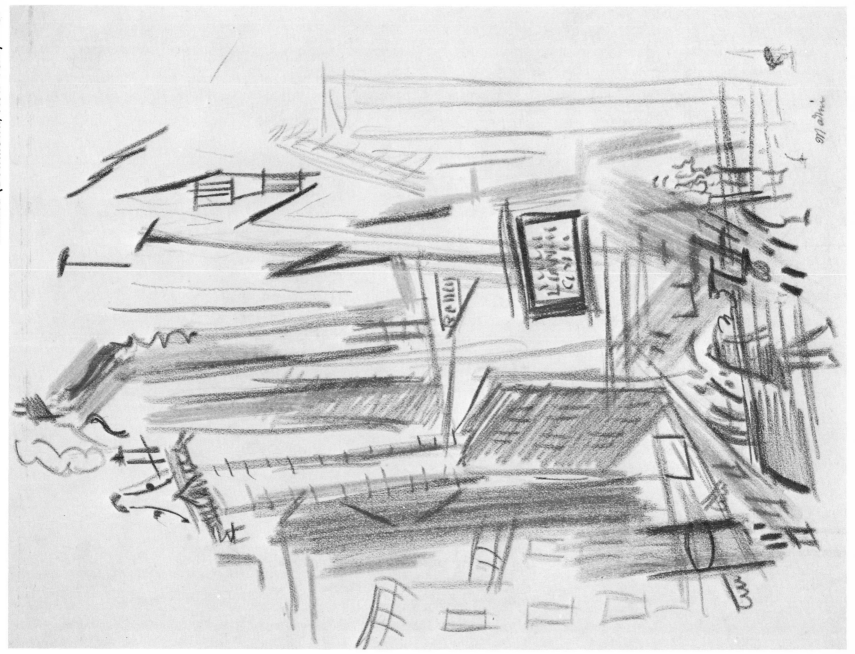

Untitled (Movement Downtown New York)

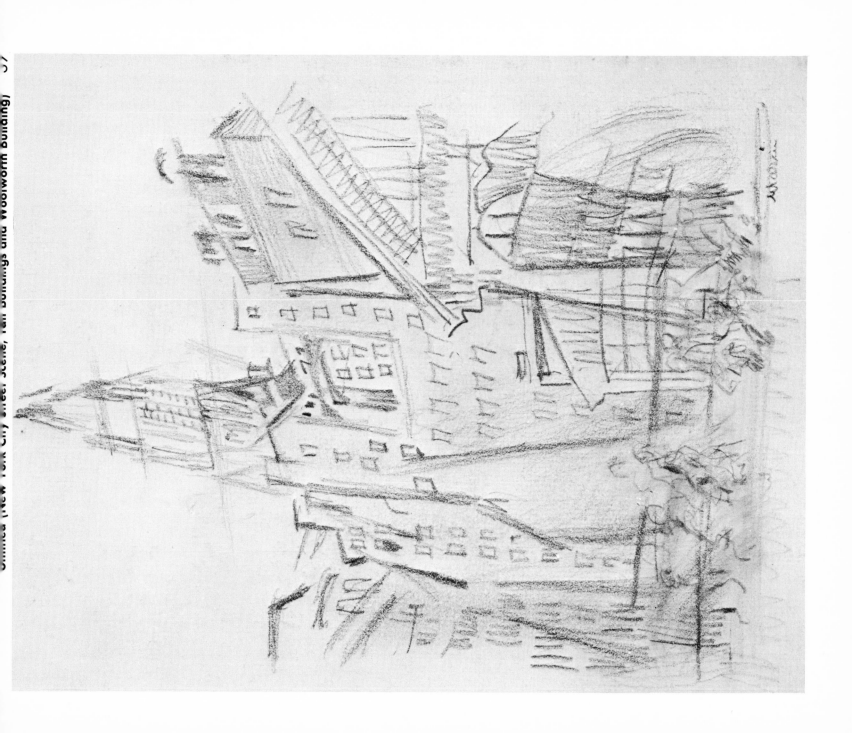

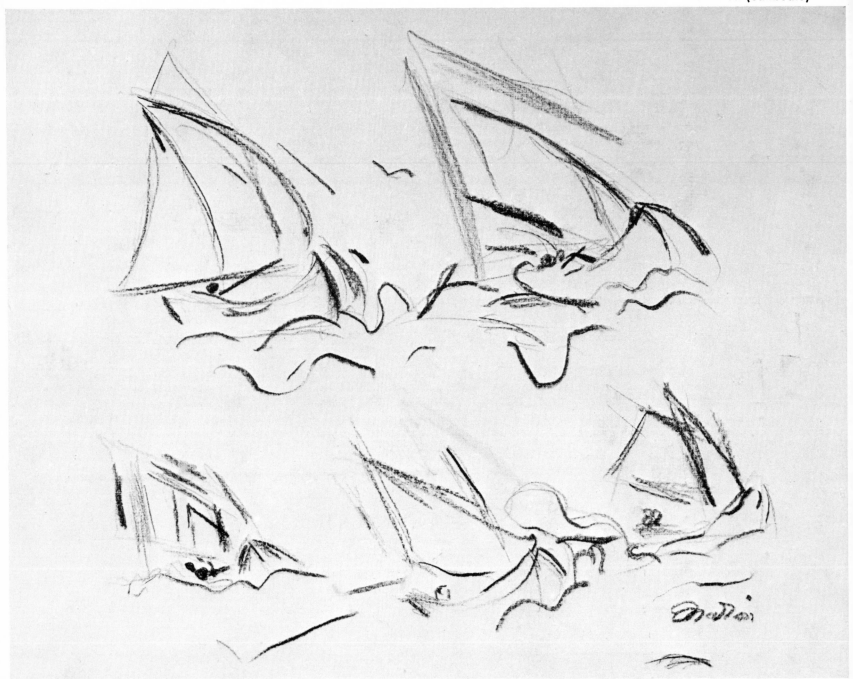

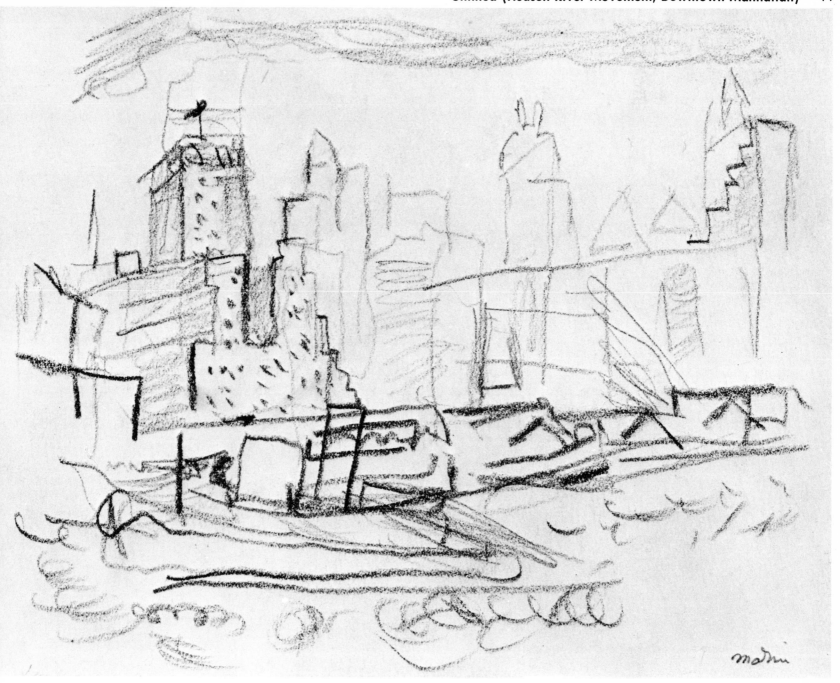

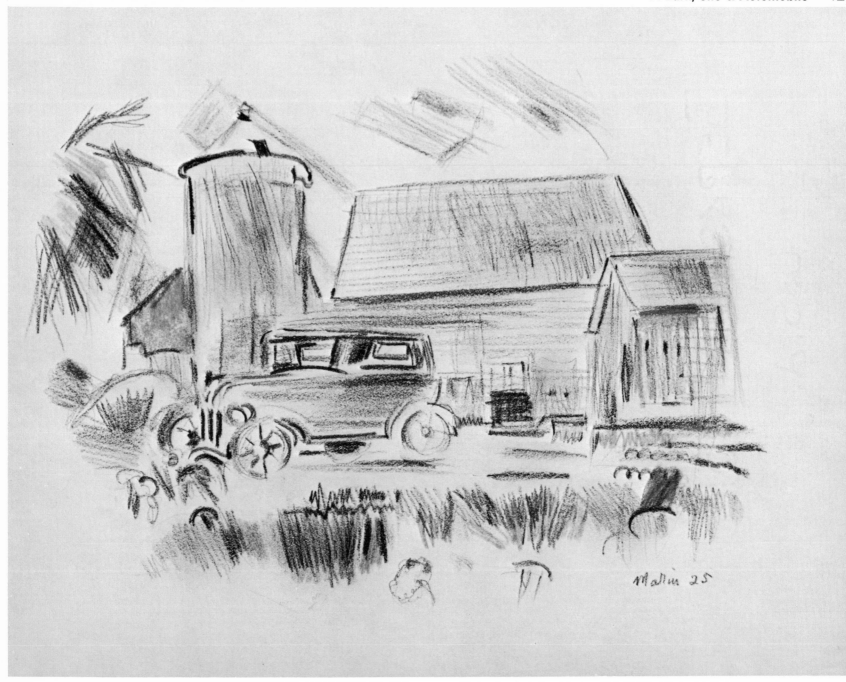

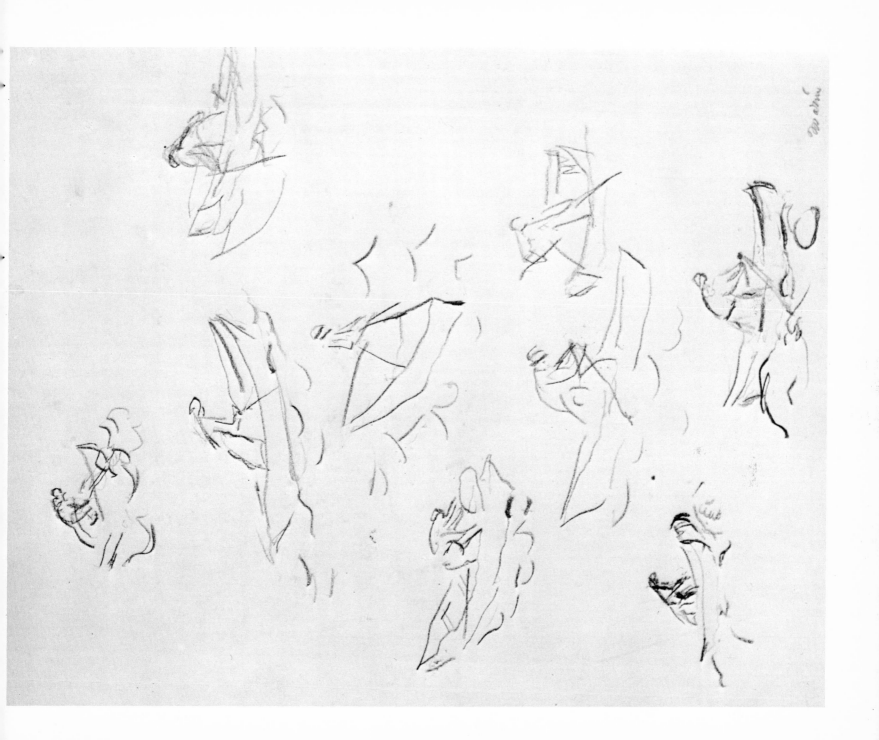

63

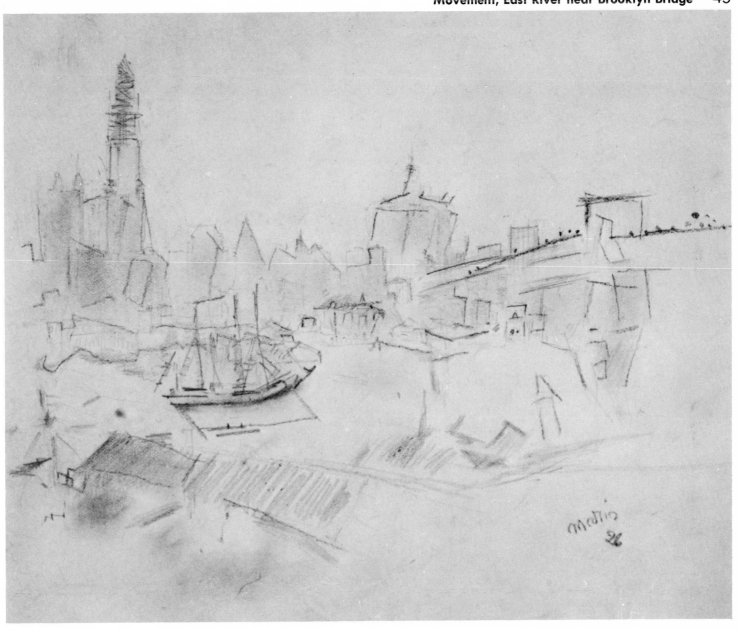

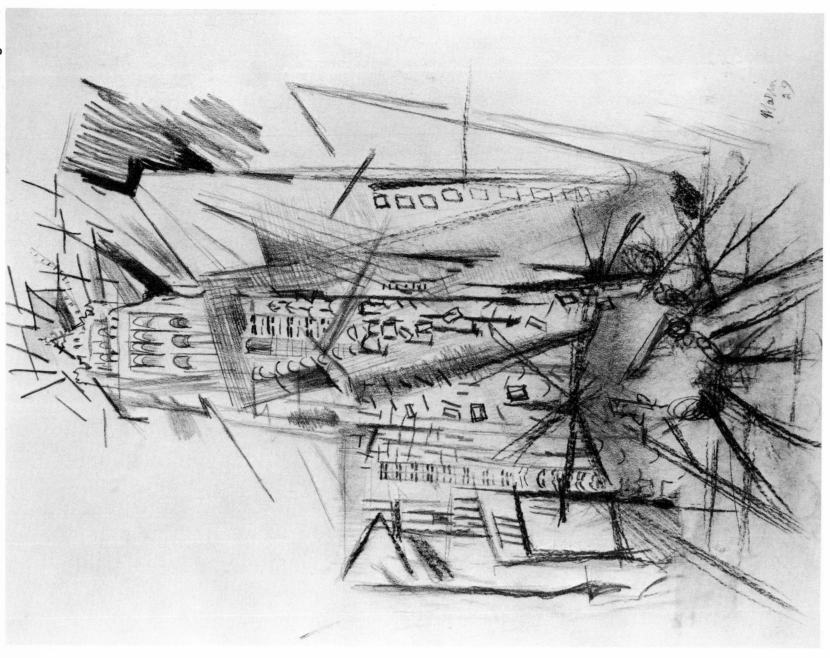

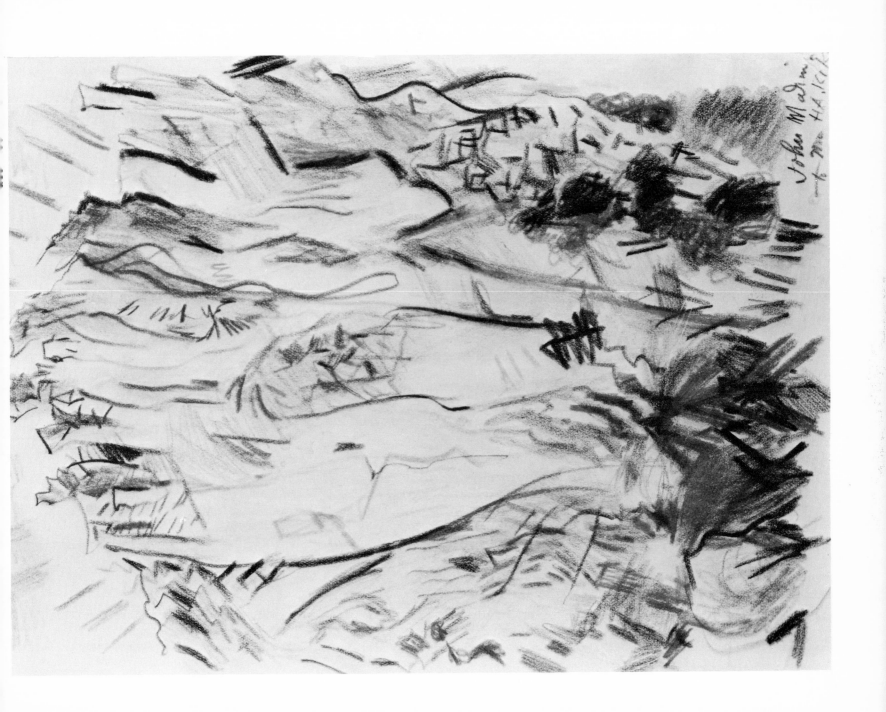

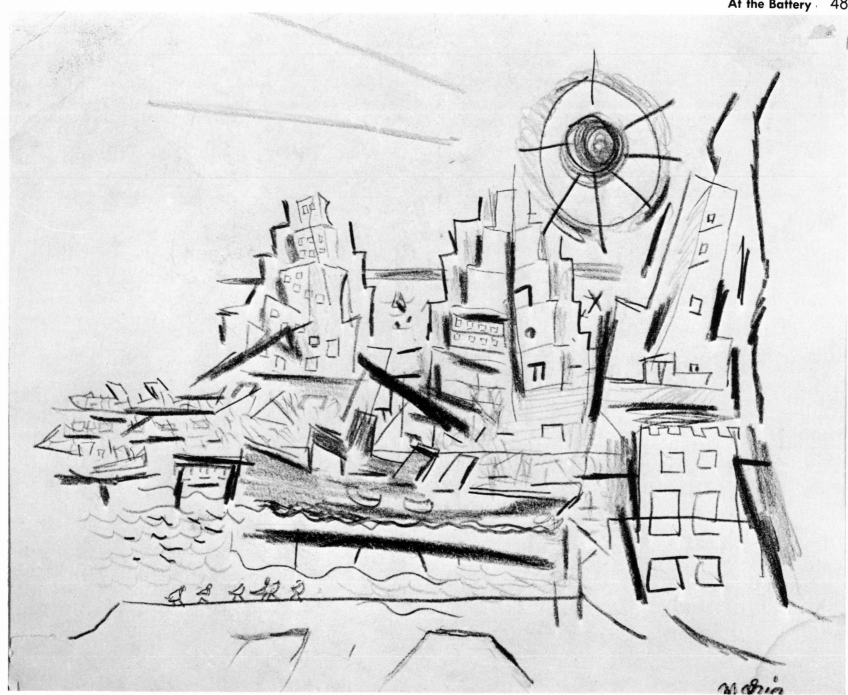

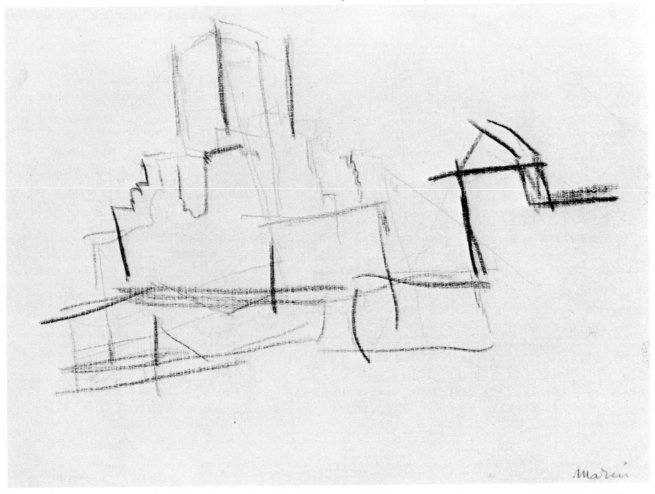

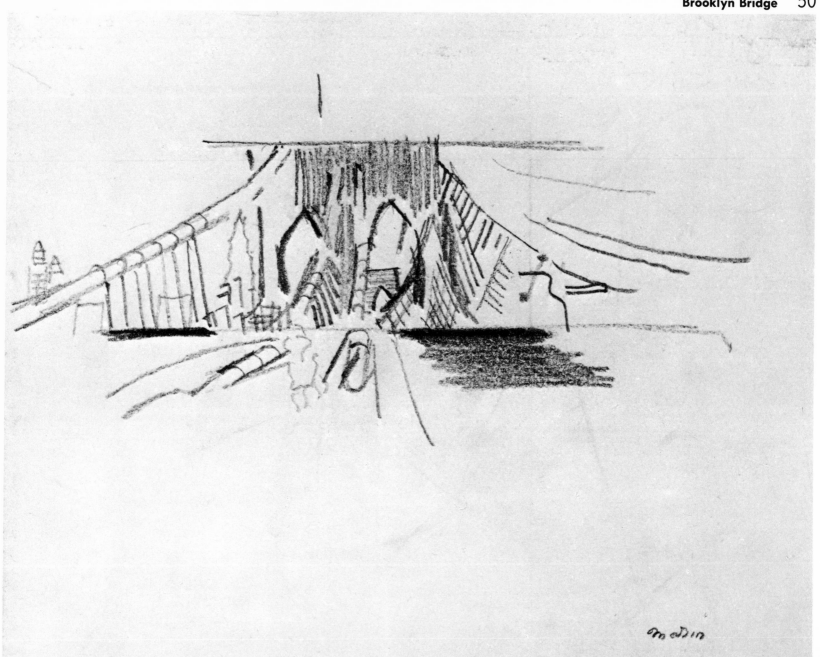

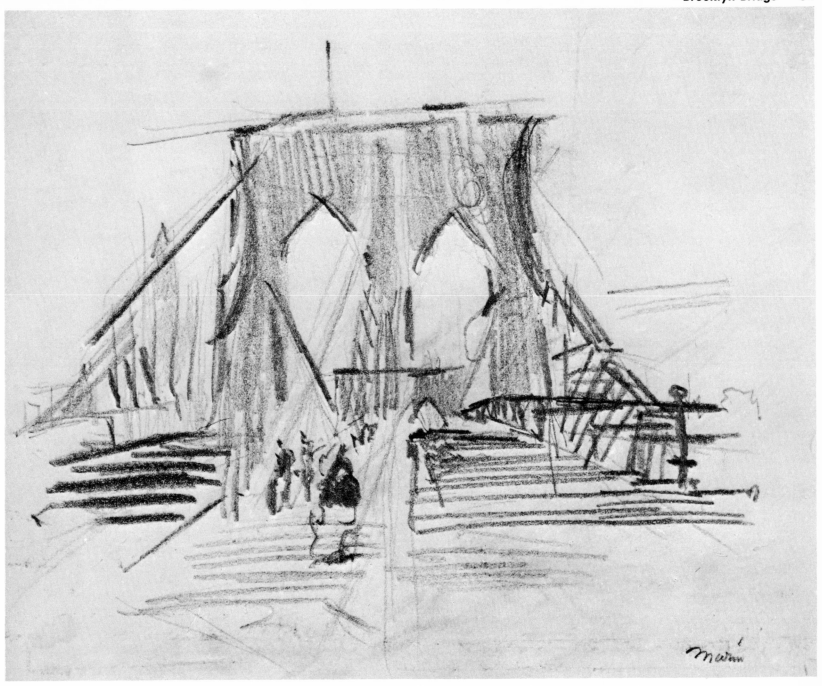

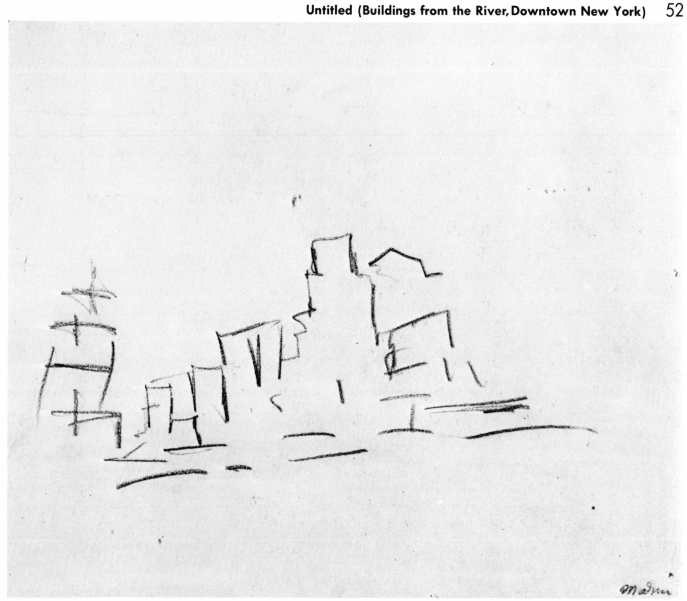

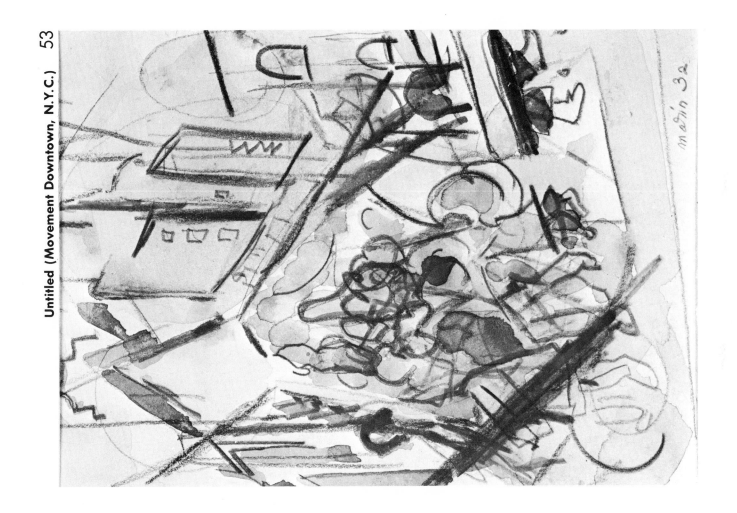

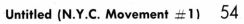

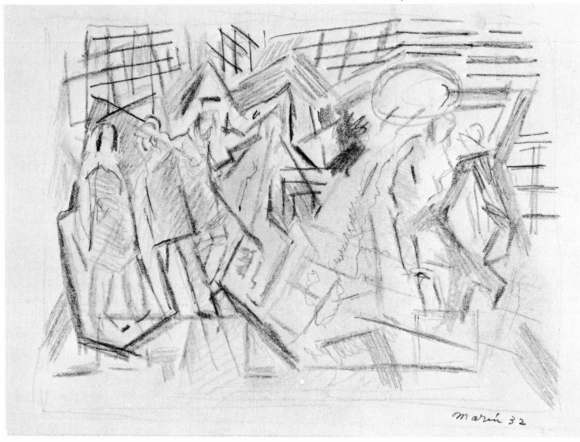

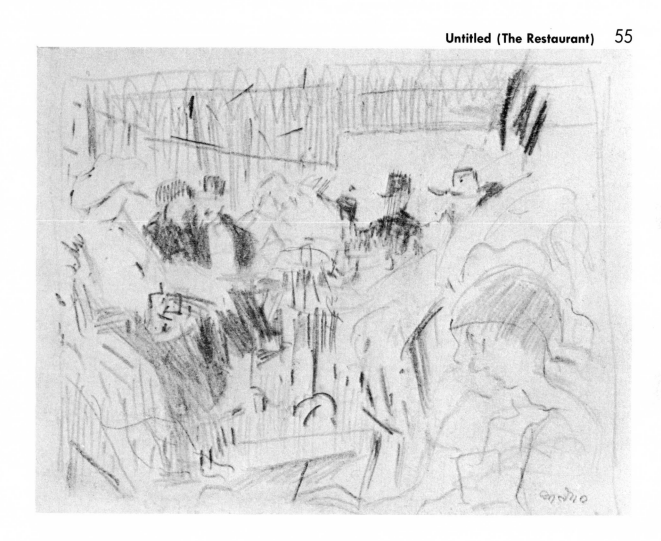

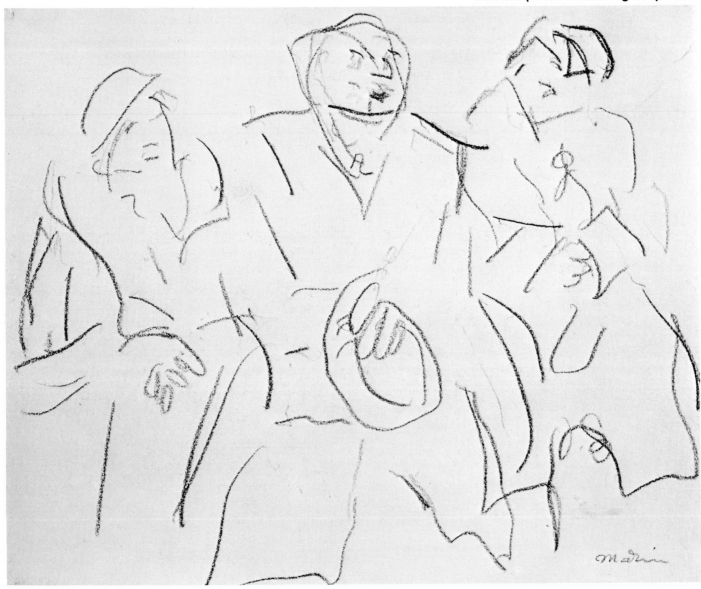

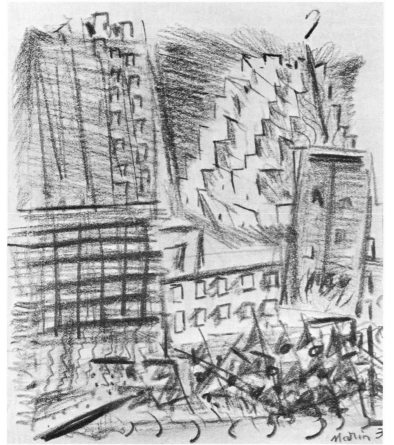

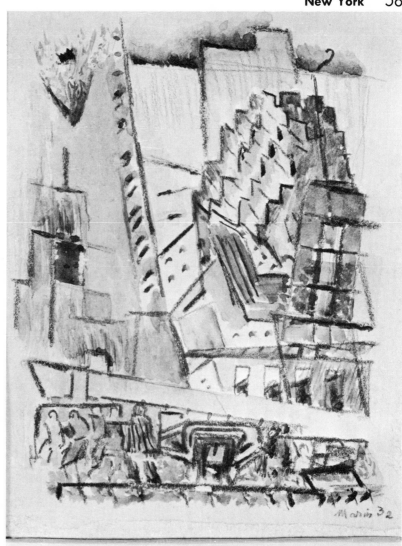

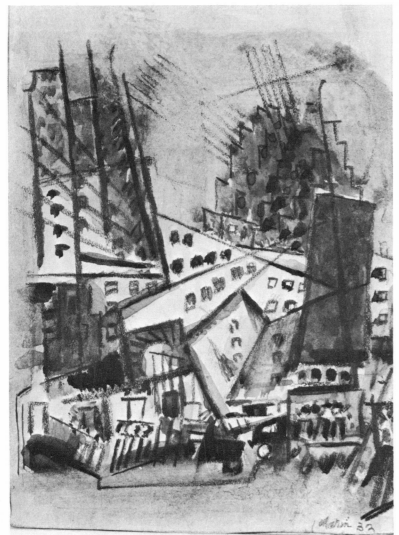

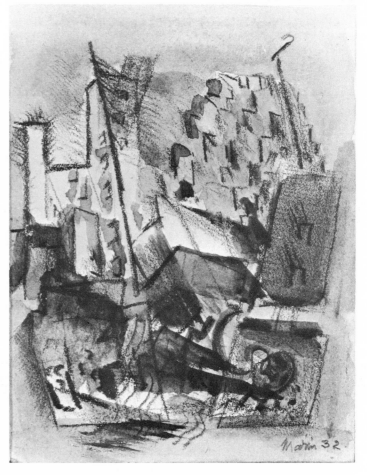

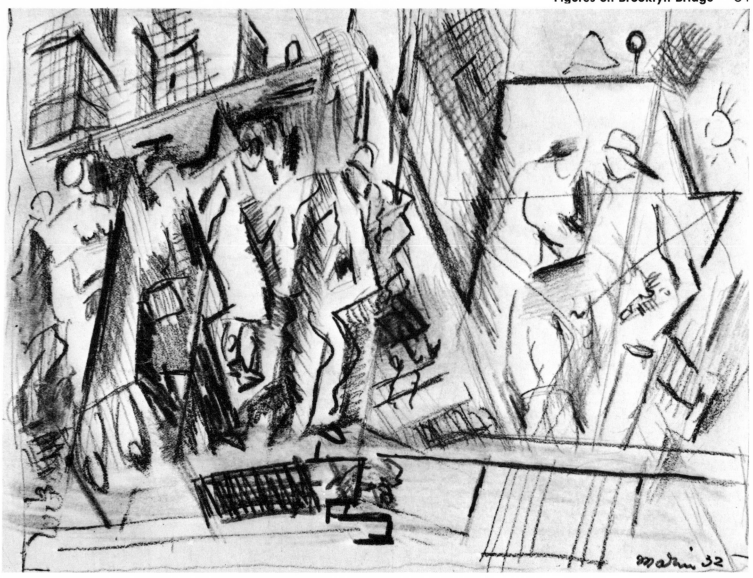

Untitled (Grouping of Figures) 62

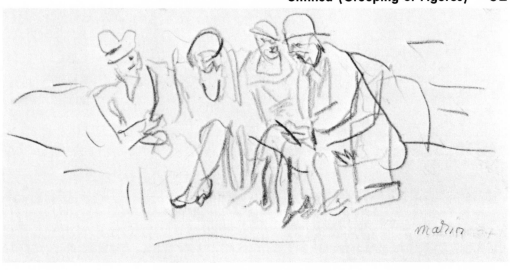

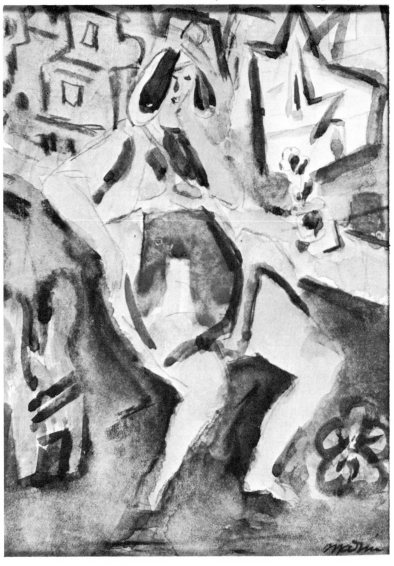

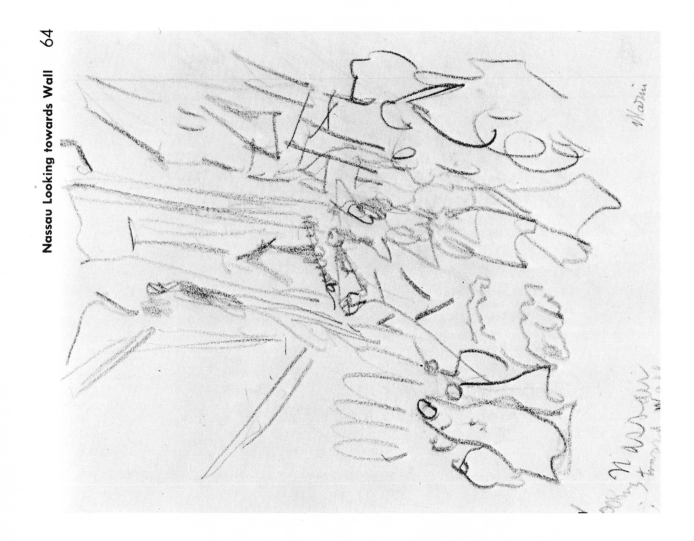

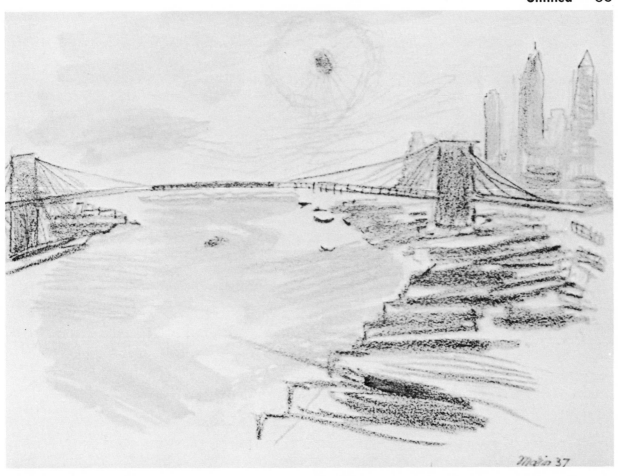

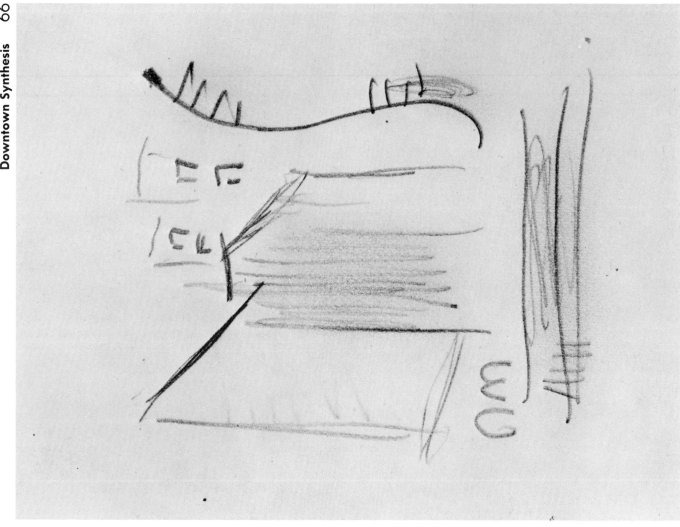

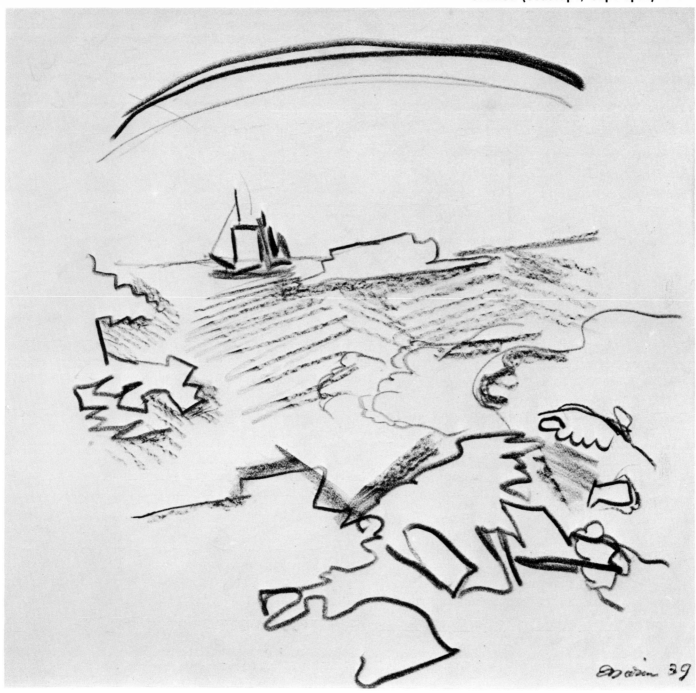

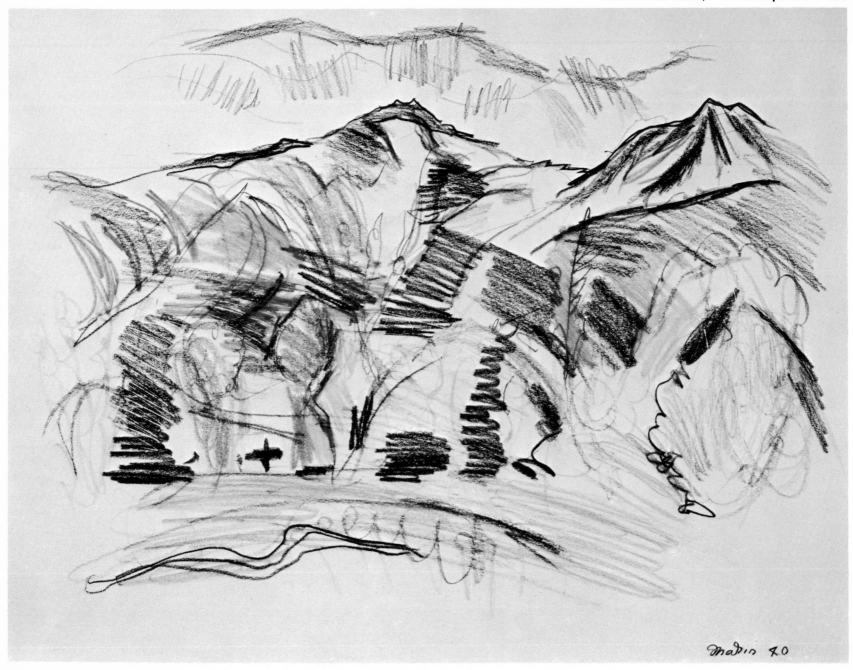

Marin 40

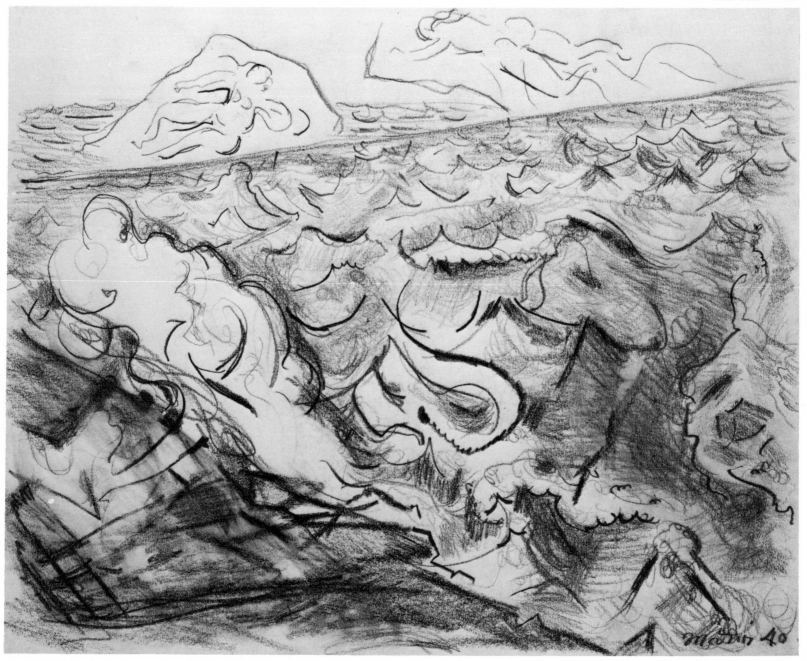

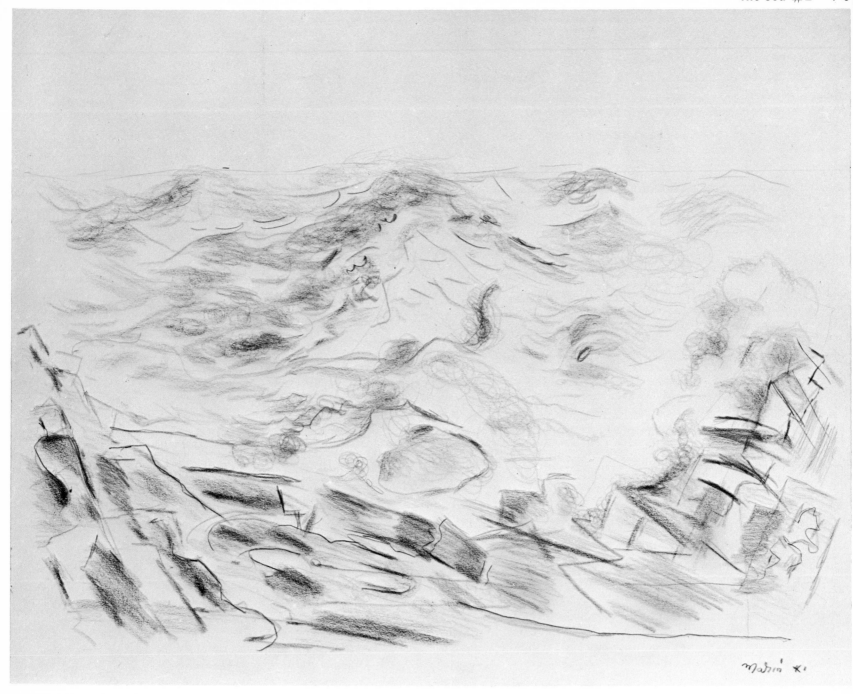

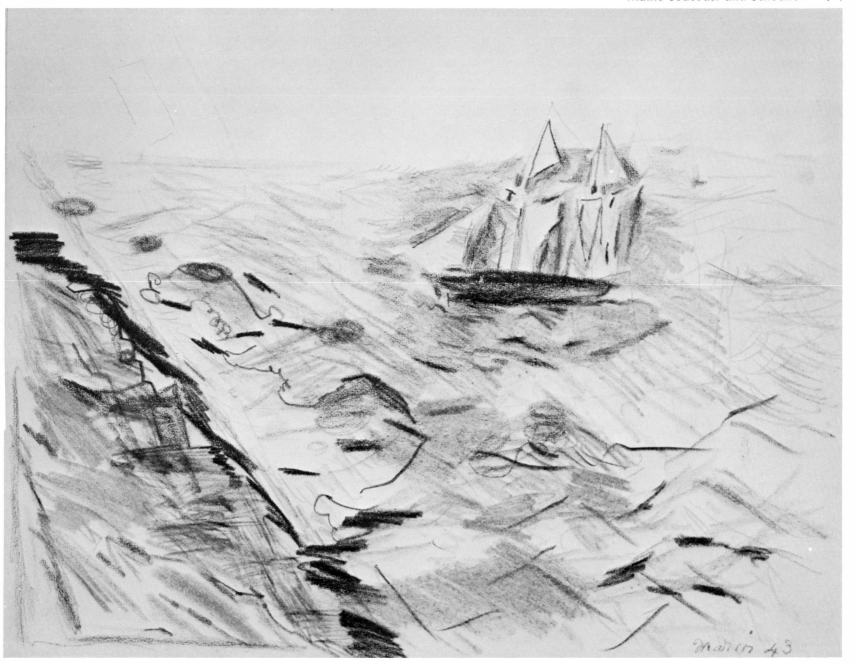

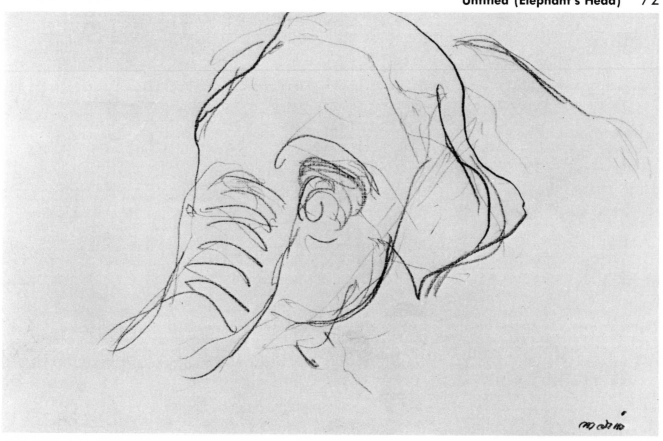

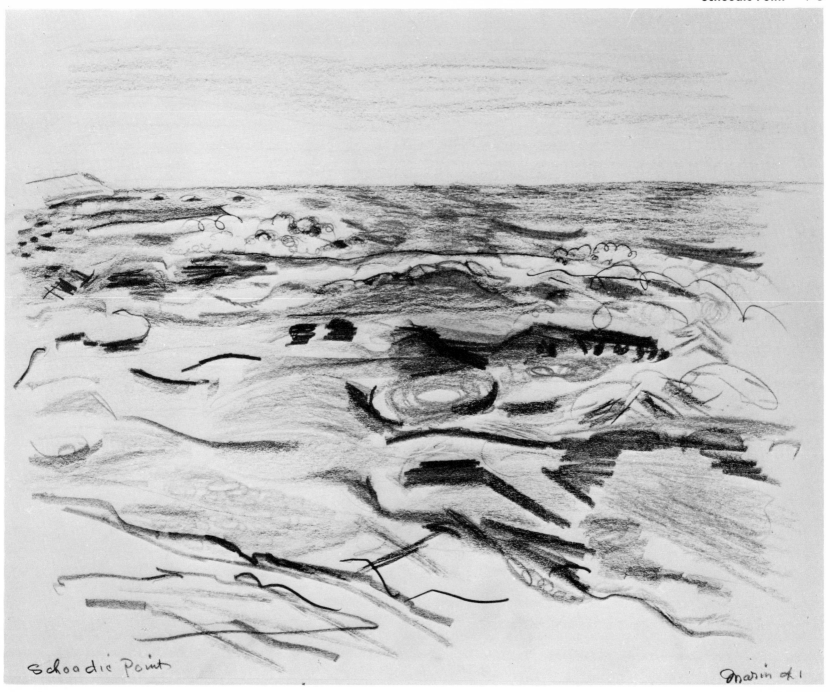

Schoodic Point

Marin 41

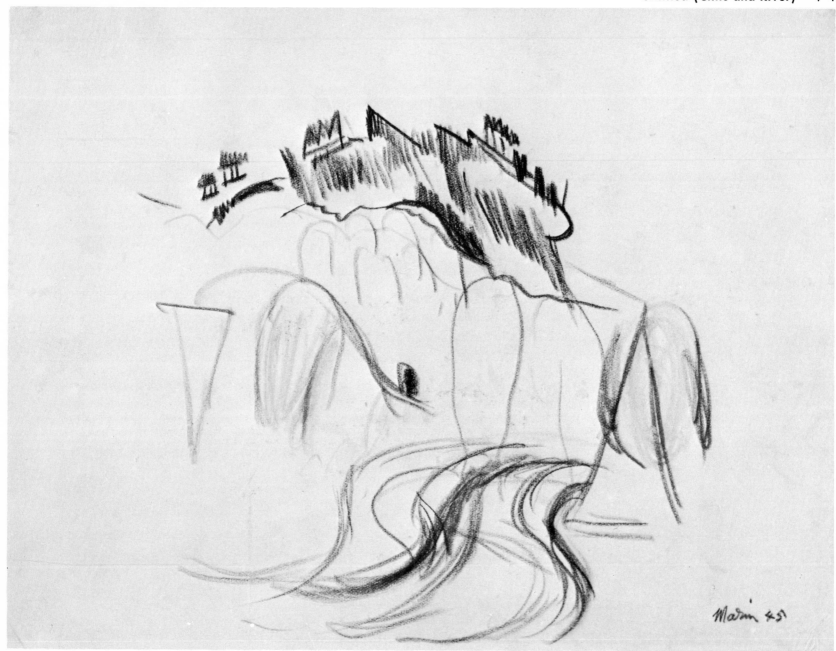

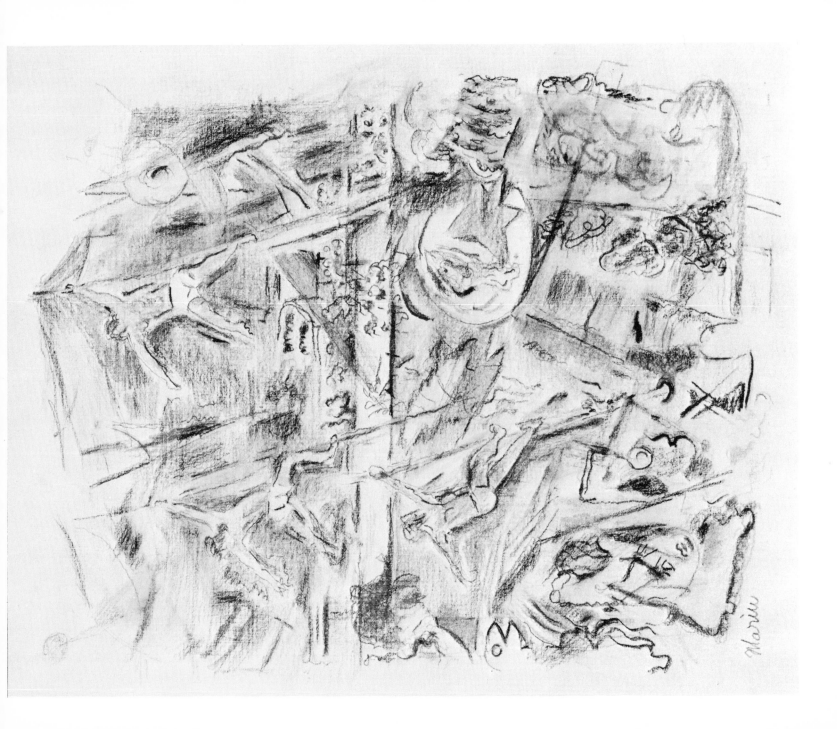

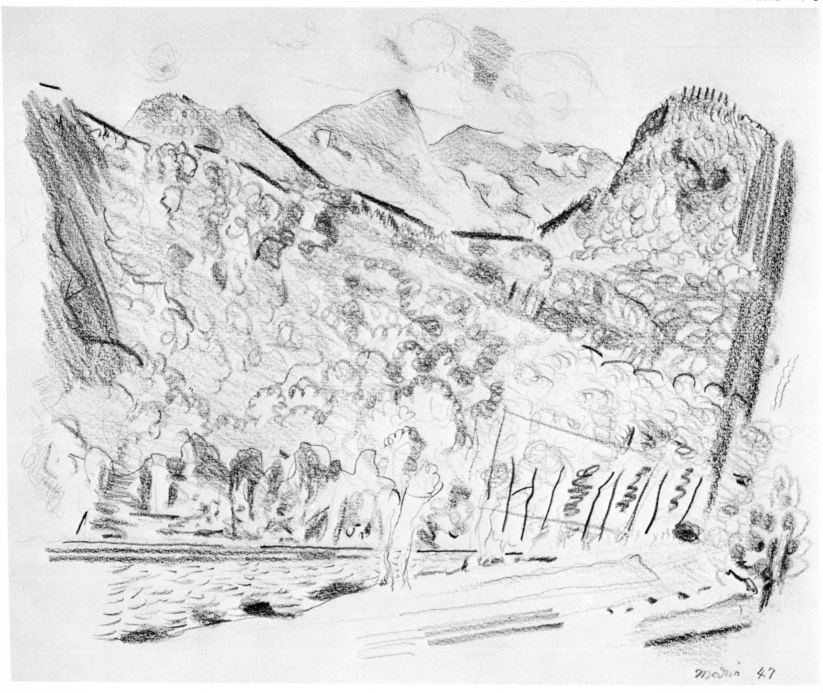

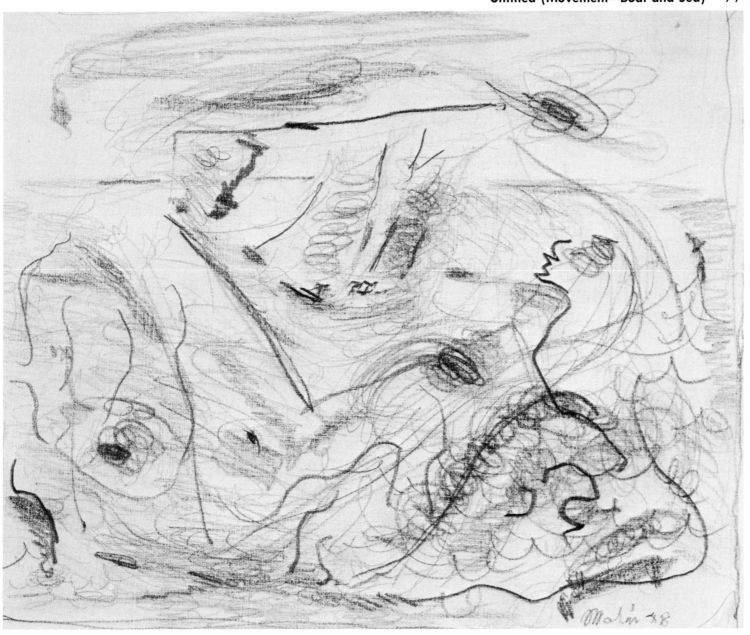

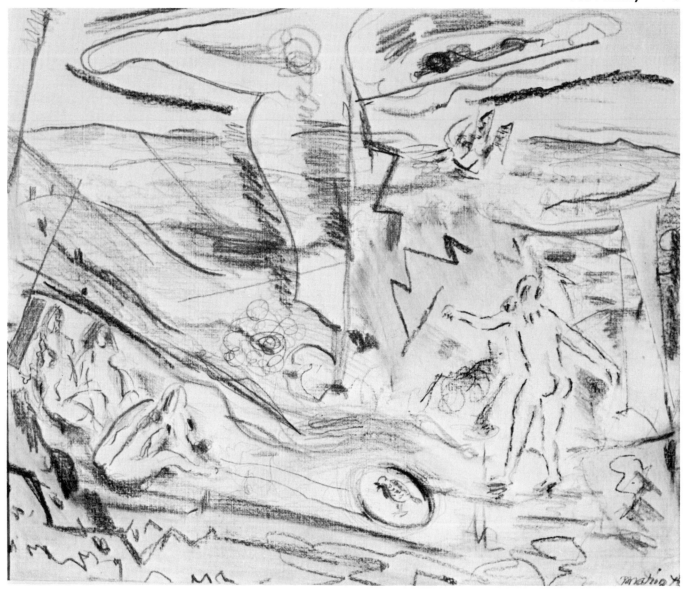

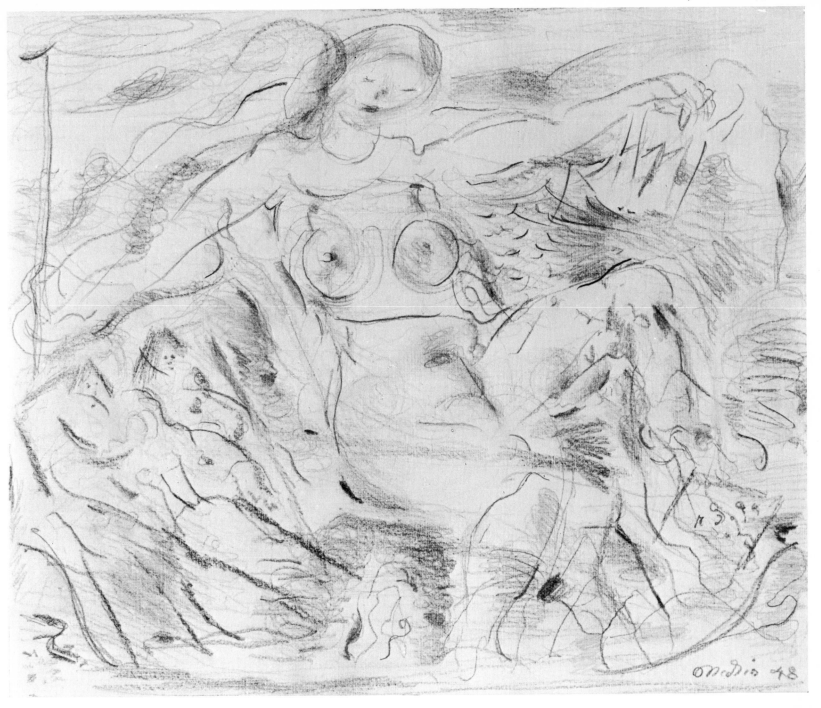

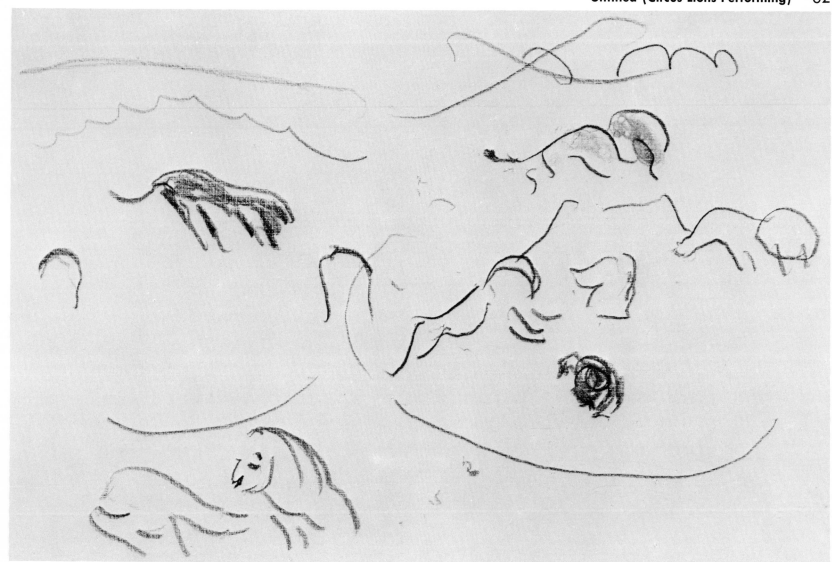

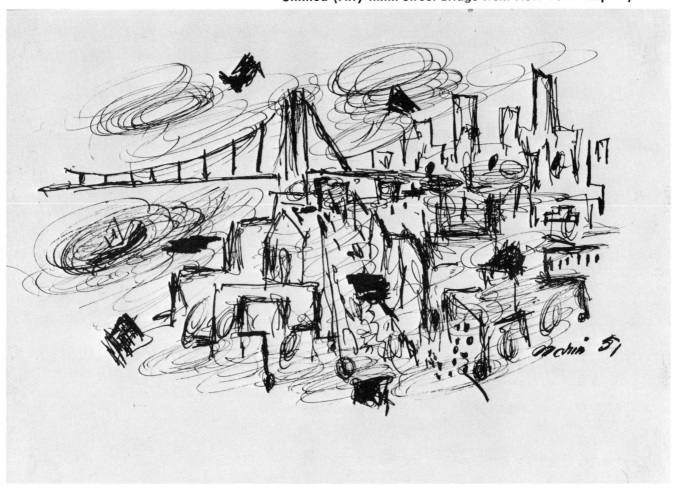

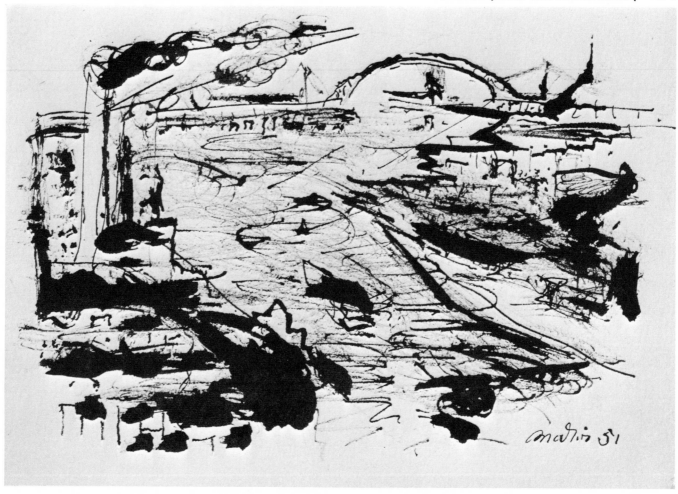

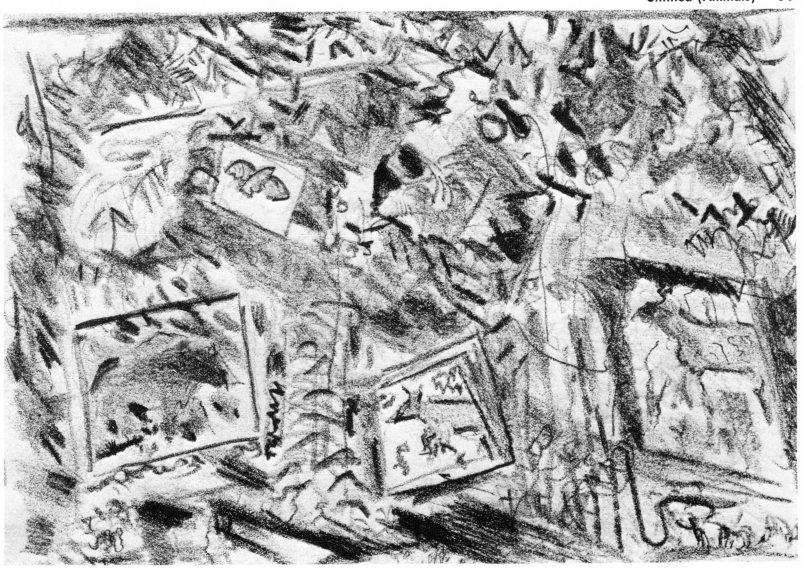

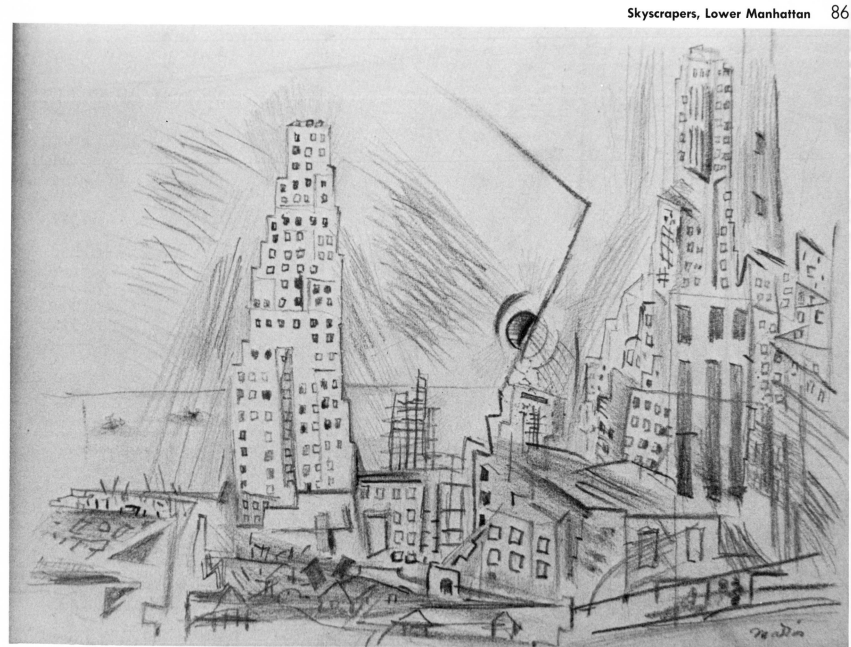

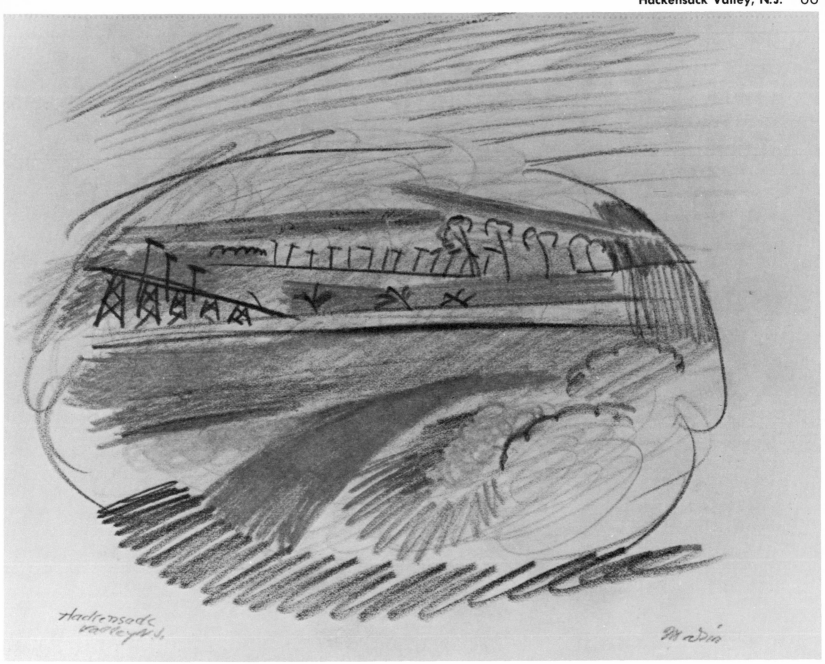

Hackensack
valley N.J.

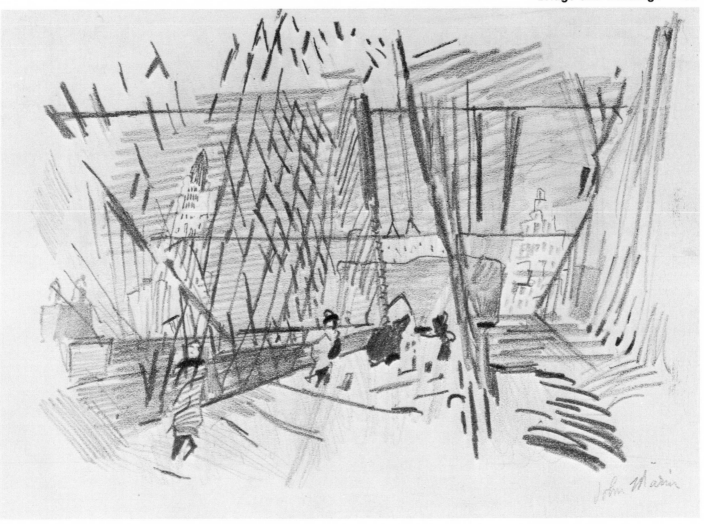

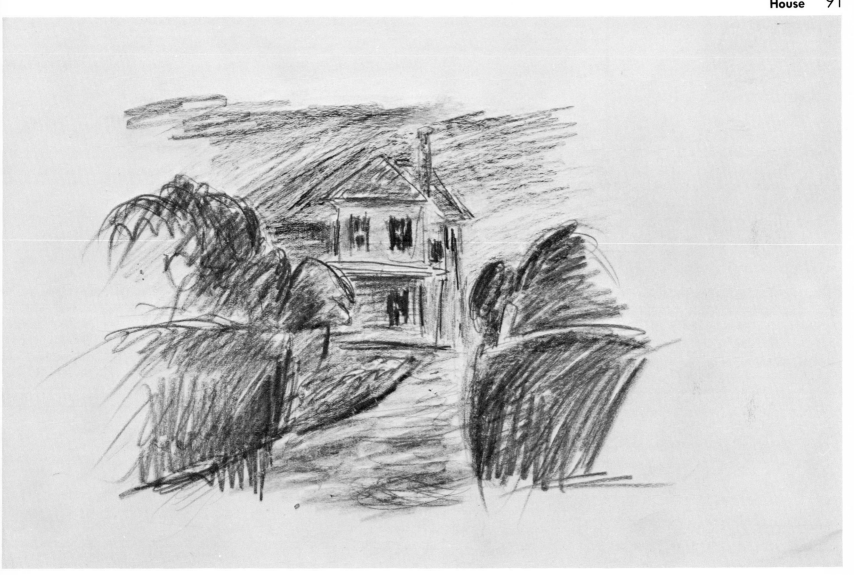

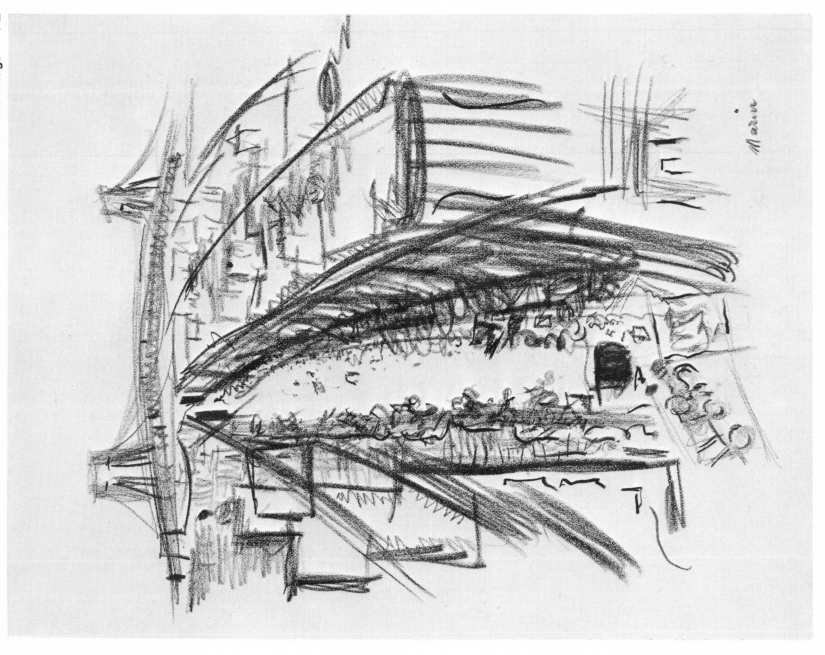

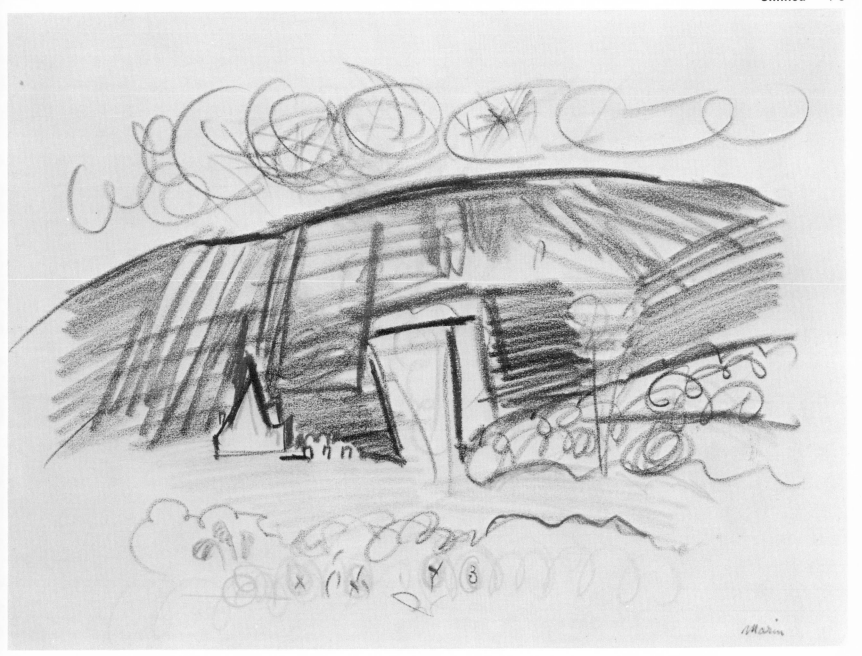

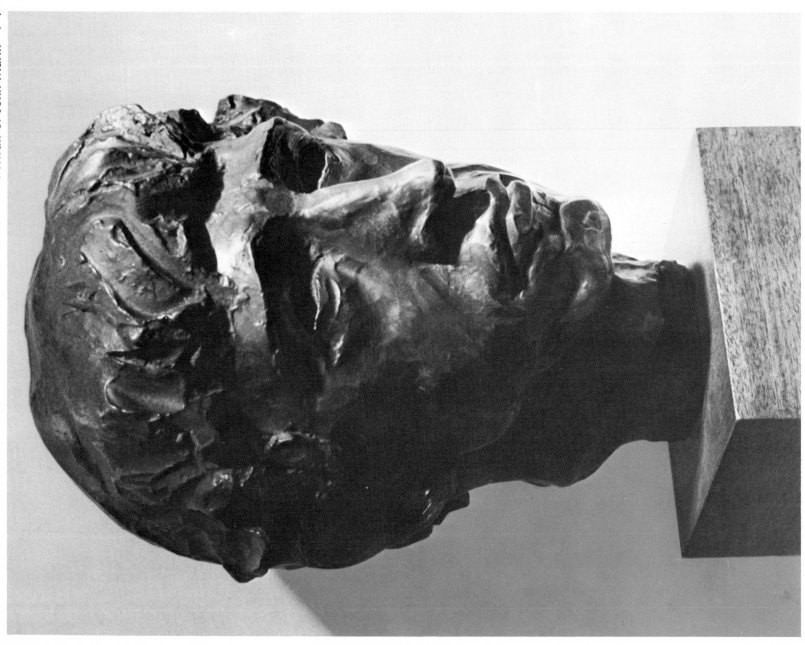

CATALOG

(Note, all works, unless otherwise indicated, are courtesy of the John Marin estate, New York

1

Catskill Mountains
Pencil, 7½ x 9½. 1886
Signed, dated and titled lower right

2

Vicinity, West New York, N.J.
Pencil, 7 x 10. 1893
Signed lower right

3

Bull's Ferry Road, West New York, N.J.
Pencil, 7 x 10. 1893
Signed lower right

4

The Harbor
Ink, 13 x 17. 1898
Signed and dated lower right

5

Untitled (Lions in the Zoo)
Pencil on heavy paper, 7¹⁵/₁₆ x 10⅞. 1895
Signed lower right
Courtesy Marlborough-Gerson Gallery, N.Y.

6

Along the River
Ink, 8 x 11½. 1900
Signed and dated lower right

7

Untitled (Barn and Farm Buildings)
Ink, 9⅝ x 11½. 1903
Signed and dated lower right

8

West Shore—River Front, Weehawken, N.J.
Ink, 7¾ x 10. 1903

9

Untitled (Street Scene)
Pastel, 8¾ x 11¾. 1905
Signed and dated lower right

10

Barges
Pen and ink, 10 x 7½. 1905
University Art Collections
Arizona State University

11

Ships at Dock
Ink, 5¾ x 8. 1905
Delaware Art Center
Wilmington, Delaware

12

Wall Street
Pencil, 8 x 9½. 1905
Yale Collection of American Literature
The Beinecke Rare Book and Manuscript
Library, New Haven, Connecticut

13

Carnival #2
Pastel and pencil, 13 x 10. 1905
Milwaukee Art Center Collection
Gift of Mr. & Mrs. Lawrence A. Fleischman
in honor of Edward H. Dwight
Milwaukee, Wisconsin

14

Untitled (Central Park Lagoon and Bldgs.)
Ink, 8¾ x 6¾. 1905
Signed and dated lower right

15

Untitled (Dock Scene)
Ink, 7¾ x 10. 1906
Signed and dated lower right

16

London—The Thames
Pencil, 6¼ x 8¾. 1906

17

Street Scene
Pencil, 14¾ x 11. 1908
Signed and dated lower left

18

Paris
Pencil, 4¼ x 5⅜. 1910
Signed, titled and dated lower left

19

East River & Brooklyn Bridge
Pencil, 8¼ x 10¾. 1910
Signed lower right

20

**Untitled (Grain Elevators and New York
Skyline from Boulevard East,
Weehawken, N.J.)**
Pencil, 8 x 10. 1912
Courtesy Marlborough-Gerson Gallery, N.Y.

21

**Untitled (Municipal Building in
Construction, N.Y.C.)**
Pencil, 10 x 7¹⁵⁄₁₆. 1912
Courtesy Marlborough-Gerson Gallery, N.Y.

22

Untitled (Brooklyn Bridge)
Pencil, 5 x 4. 1913
Signed lower left
Courtesy Marlborough-Gerson Gallery, N.Y.

23

Brooklyn Bridge
Pencil, mounted on board, 8¾ x 8. 1913
Signed lower right

24

Untitled (Woolworth Building)
Pencil, 9½ x 7⅜. 1913
Signed lower left
Courtesy Marlborough-Gerson Gallery, N.Y.

25

Brooklyn Bridge
Pencil, 4½ x 6⅜. 1913
Signed lower right, titled lower left

26

Brooklyn Bridge
Pencil, 7 x 5½. 1913
Signed lower right

27

**Untitled (New York Skyline from
Boulevard East, Weehawken, N.J.)**
Pencil, 8 x 9½. 1915
Courtesy Marlborough-Gerson Gallery, N.Y.

28

Brooklyn Bridge from Brooklyn
Pencil, mounted on board, 9½ x 11½. 1915
Signed lower right
Signed and dated lower left

29

**Untitled (West Shore Railroad Yard and
Grain Elevators at Weehawken, N.J.)**
Pencil, 10½ x 8. 1915
Signed lower right
Courtesy Marlborough-Gerson Gallery, N.Y.

30

**Untitled (Abstraction of Buildings and
Natural Forms, Weehawken, N.J.)**
Pencil, 11 x 8½. 1915
Courtesy Marlborough-Gerson Gallery, N.

31

**Untitled, Abstraction (Grain Elevators),
Weehawken, N.J.**
Pencil, 8½ x 11. 1916
Signed lower left
Courtesy Marlborough-Gerson Gallery, N.

32

**Untitled (Hudson River from Boulevard
East, Weehawken, N.J.)**
Pencil, 8½ x 11. 1916
Signed lower right
Courtesy Marlborough-Gerson Gallery, N.

33

New York Scene
Crayon or colored pencil, 20 x 27. 1920
Mr. & Mrs. James M. K. Waldron
Reading, Pennsylvania

34

**New York from Dyckman Street
Ferry Hill No. 1**
Pencil, 9¾ x 12½. 1921

35

Untitled (New York Stock Exchange)
Pencil, $9\frac{13}{16}$ x $7\frac{7}{16}$. 1924
Signed lower right
Courtesy Marlborough-Gerson Gallery, N.Y.

36

White Mountains, New Hampshire
Crayon, $6\frac{1}{2}$ x 10. 1924
Titled lower left
Signed lower right

37

Untitled (Downtown, New York)
Colored pencil, $9\frac{3}{4}$ x $7\frac{13}{16}$. 1924
Signed lower right
Courtesy Marlborough-Gerson Gallery, N.Y.

38

Untitled (Movement Downtown New York)
Pencil on linen, $8\frac{3}{16}$ x $6\frac{5}{8}$. 1924
Courtesy Marlborough-Gerson Gallery, N.Y.

39

**Untitled (New York City Street Scene
Tall Buildings and Woolworth Building)**
Pencil, $8\frac{1}{2}$ x $6\frac{5}{8}$. 1924
Signed lower right
Courtesy Marlborough-Gerson Gallery, N.Y.

40

Untitled (Sailboats)
Black crayon, mounted on board, 8 x 10. 1925
Signed lower right

41

**Untitled (Hudson River Movement,
Downtown Manhattan)**
Pencil, $5\frac{1}{8}$ x $6\frac{3}{4}$. 1925
Signed lower right
Courtesy Marlborough-Gerson Gallery, N.Y.

42

A Barn, Silo & Automobile
Crayon and pencil, $8\frac{1}{2}$ x 11. 1925
Signed lower left
Collection Mrs. S. Davidson Lowe, New York

43

Untitled (Studies of Man in Rowboat)
Pencil, mounted on board, 10 x 8. 1925
Signed lower right

44

Untitled (Movement, 5th Avenue, N.Y.C.)
Pencil, $8\frac{3}{16}$ x $6\frac{5}{8}$. 1926
Courtesy Marlborough-Gerson Gallery, N.Y.

45

Movement, East River near Brooklyn Bridge
Pencil, $5\frac{1}{4}$ x $7\frac{3}{4}$. 1926
Mr. & Mrs. William H. Bender, Jr., New York

46

Woolworth Building
Pencil, $10\frac{3}{4}$ x $8\frac{1}{2}$. 1929
Mr. Richard Sisson, New York

47

Taos Mountains
Pastel, $7\frac{1}{4}$ x $9\frac{1}{2}$. 1929
Mr. and Mrs. Henry Pearlman, New York

48

At the Battery
Pencil (recto verso) $6\frac{3}{4}$ x $9\frac{5}{8}$. 1930
Signed lower right

49

**Untitled (New York Skyline with
Telephone Building)**
Pencil, 5 x $6\frac{7}{8}$. 1931
Signed lower right
Courtesy Marlborough-Gerson Gallery, N.Y.

50

Brooklyn Bridge
Pencil, mounted on board, $6\frac{3}{4}$ x $8\frac{11}{16}$. 1931
Signed lower right

51

Brooklyn Bridge
Pencil, mounted on board, 7 x $8\frac{3}{4}$. 1931
Signed lower right

52

**Untitled (Buildings from the River
Downtown New York)**
Pencil, 6 x $7\frac{1}{4}$. 1932
Signed lower right
Courtesy Marlborough-Gerson Gallery, N.Y.

53

Untitled (Movement Downtown, N.Y.C.)
Watercolor and pencil on board,
6 13/16 x 4¾. 1932
Signed and dated lower right
Courtesy Marlborough-Gerson Gallery, N.Y.

54

Untitled (N.Y.C. Movement #1)
Pencil on paper, 4½ x 6³/₁₆. 1932
Signed and dated lower right
Courtesy Marlborough-Gerson Gallery, N.Y.

55

Untitled (The Restaurant)
Pencil, 4⅞ x 6⅜. 1932
Signed lower right
Courtesy Marlborough-Gerson Gallery, N.Y.

56

Untitled (Three Seated Figures)
Pencil, 5⁵/₁₆ x 7⁷/₁₆. 1932
Signed lower right
Courtesy Marlborough-Gerson Gallery, N.Y.

57

New York
Pencil and watercolor, 4⁹/₁₆ x 4. 1932
The Metropolitan Museum of Art
The Alfred Stieglitz Collection
New York, 1949.

58

New York
Pencil and watercolor, 5⁹/₁₆ x 4¼. 1932
The Metropolitan Museum of Art
The Alfred Stieglitz Collection
New York, 1949.

59

New York
Pencil and watercolor, 5½ x 4⅛. 1932
The Metropolitan Museum of Art
The Alfred Stieglitz Collection
New York, 1949.

60

New York
Pencil and watercolor, 4¾ x 3 11/16. 1932
The Metropolitan Museum of Art
The Alfred Stieglitz Collection
New York, 1949.

61

Figures on Brooklyn Bridge
Pencil, 6½ x 8. 1932
Santa Barbara Museum of Art
Anonymous gift to the Donald Bear
Memorial Collection, Santa Barbara, Calif.

62

Untitled (Grouping of Figures)
Pencil, 2⅝ x 5⁷/₁₆. 1934
Signed lower right
Courtesy Marlborough-Gerson Gallery, N.

63

Untitled (Seated Female Figure)
Watercolor and pencil, 5¾ x 4⅛. 1935
Signed lower right
Courtesy Marlborough-Gerson Gallery, N

64

Nassau Looking towards Wall
Pencil, 5⁷/₁₆ x 5. 1936
Signed lower right, titled lower left
Courtesy Marlborough-Gerson Gallery, N

65

Untitled
Pencil and crayon on paper, 4¾ x 6½. 19
Signed lower left
Collection Mrs. Elizabeth Bodkin, New Yo

66

Downtown Synthesis
Pencil, 4¾ x 3½. 1937
Philadelphia Museum of Art
Philadelphia, Pennsylvania

67

Untitled (Seascape, Cape Split)
Black crayon, 7 x 7⅝. 1939
Signed and dated lower right

68

White Mountains, New Hampshire
Crayon and pencil, 11 x 14. 1940
Signed and dated lower right

69

The Sea
Black crayon, 21⅞ x 24. 1940
National Gallery of Art, Washington, D.C.
Gift of Mr. and Mrs. Frank Eyerly
Washington, D.C.

70

The Sea #2
Pencil, 19¾ x 13¾. 1941
Signed and dated lower right
Courtesy Marlborough-Gerson Gallery, N.Y.

71

Maine Seacoast and Schooner
Colored pencil, 7½ x 10⅞. 1943
Elizabeth Davidson Bodkin, New York

72

Untitled (Elephant's Head)
Pencil on linen paper, 4 $\frac{13}{16}$ x 7⅛. 1944
Signed lower right
Courtesy Marlborough-Gerson Gallery, N.Y.

73

Schoodic Point
Colored pencil, 11 1/16 x 13 15/16. 1941
Titled lower left
Signed and dated lower right
Courtesy Marlborough-Gerson Gallery, N.Y.

74

Untitled (Cliffs and River)
Crayon, 7½ x 10. 1945
Signed and dated lower right

75

Untitled (Trapeze Performers)
Colored pencil, 9¾ x 7⅞. 1945
Signed lower left
Courtesy Marlborough-Gerson Gallery, N.Y.

76

Adirondacks
Pencil, 10 x 12½. 1947
Signed and dated lower right

77

Untitled (Movement—Boat and Sea)
Pencil, 6 7/16 x 7 15/16. 1948
Signed and dated lower right
Courtesy Marlborough-Gerson Gallery, N.Y.

78

Sea Fantasy
Pencil and charcoal, 6 x 7½. 1948
Signed and dated lower right

79

Untitled (Sea Fantasy)
Pencil, 6⅜ x 7 $\frac{13}{16}$. 1948
Signed and dated lower right
Courtesy Marlborough-Gerson Gallery, N.Y.

80

Untitled (Trapeze Performers)
Pencil, 6 9/16 x 7½. 1948
Courtesy Marlborough-Gerson Gallery, N.Y.

81

Untitled (The Circus)
Pencil, 11 x 13 15/16. 1948
Signed and dated lower right
Courtesy Marlborough-Gerson Gallery, N.Y.

82

Untitled (Circus Lions Performing)
Pencil, 5¾ x 8⅞. 1948
Courtesy Marlborough-Gerson Gallery, N.Y.

83

Untitled (Fifty-ninth Street Bridge from New York Hospital)
Ink, 5 x 7⅛. 1951
Signed and dated lower right
Courtesy Marlborough-Gerson Gallery, N.Y.

84

Untitled (River and Smokestacks)
Ink, 5 x 7³⁄₁₆. 1951
Signed and dated lower right

85

Untitled (Animals)
Pencil, 7¼ x 10. 1951
Signed and dated lower right

The following drawings are
undated by lenders. Dr. Reich has
suggested dates for several drawings
with which he is familiar.

86

Skyscrapers, Lower Manhattan
Pencil, 7 x 9½

87

Untitled
Pencil, 6 x 8¼. 1912
The Art Institute of Chicago
Gift of Georgia O'Keefe
Chicago, Illinois

88

Hackensack Valley, N.J.
Crayon Drawing, 7¾ x 10
Mr. and Mrs. Harry Baum
Washington, D.C.

89

Bridge and Buildings
Pencil, 7½ x 5⁵⁄₁₆. 1912
The Art Institute of Chicago
Gift of Georgia O'Keefe
Chicago, Illinois

90

Buildings
Pencil, 6¾ x 5¾. 1912
The Art Institute of Chicago
Gift of Georgia O'Keefe
Chicago, Illinois

91

House
Pencil and crayon, 9 x 5¾. 1930
The Art Institute of Chicago
Gift of Georgia O'Keefe
Chicago, Illinois

92

The Bridge
Black, yellow & orange crayon,
6¾ x 8¾. 1920
The Art Institute of Chicago
Gift of Georgia O'Keefe
Chicago, Illinois

93

Untitled
Crayon drawing, 7½ x 10
Mr. and Mrs. Myer L. Orlov
Brookline, Massachusetts

94

Portrait of John Marin
Gaston Lachaise, bronze. 1928
Milwaukee Art Center Collection
Gift of the Milwaukee Journal